One Work is a unique series of books published by Aft~ ~ased
at Central Saint Martins College of Art and D~ ~.
Each book presents a single work of a~~
a single author. The focus of th~
and its aim is to provoke deb
art's recent development.

Over the course of more than on ~oks, important works
will be presented in a meticulous ~ ~enerous manner by writers
who believe passionately in the originality and significance of the
works about which they have chosen to write. Each book contains
a comprehensive and detailed formal description of the work,
followed by a critical mapping of the aesthetic and cultural context
in which it was made and has gone on to shape. The changing
presentation and reception of the work throughout its existence
is also discussed, and each writer stakes a claim on the influence
'their' work has on the making and understanding of other
works of art.

The books insist that a single contemporary work of art (in all
of its different manifestations), through a unique and radical
aesthetic articulation or invention, can affect our understanding
of art in general. More than that, these books suggest that a single
work of art can literally transform, however modestly, the way
we look at and understand the world. In this sense the *One Work*
series, while by no means exhaustive, will eventually become
a veritable library of works of art that have made a difference.

First published in 2013
by Afterall Books

Afterall
Central Saint Martins
College of Art and Design,
University of the Arts London
Granary Building
1 Granary Square
London N1C 4AA
www.afterall.org

ISBN Paperback: 978-1-84638-095-2
ISBN Cloth: 978-1-84638-094-5

Distribution by The MIT Press,
Cambridge, Massachusetts and London
www.mitpress.mit.edu

Art Direction and Typeface Design
A2/SW/HK

Printed and bound by
Die Keure, Belgium

The One Work series is printed
on FSC-certified papers

Supported using public funding by

ARTS COUNCIL
ENGLAND

An Afterall Book
Distributed by The MIT Press

Sanja Iveković
Triangle

Ruth Noack

One Work Series Editor
Mark Lewis

Afterall Books
Editorial Directors
Charles Esche and
Mark Lewis

Editor
Pablo Lafuente

Managing Editor
Gaia Alessi

Associate Editor
Caroline Woodley

Editorial Assistant
Louise O'Hare

Copy Editor
Deirdre O'Dwyer

Other titles in the
One Work series:

*Bas Jan Ader: In Search
of the Miraculous*
by Jan Verwoert

Hollis Frampton: (nostalgia)
by Rachel Moore

*Ilya Kabakov: The Man
Who Flew into Space
from his Apartment*
by Boris Groys

*Richard Prince:
Untitled (couple)*
by Michael Newman

*Joan Jonas: I Want to
Live in the Country
(And Other Romances)*
by Susan Morgan

*Mary Heilmann:
Save the Last Dance for Me*
by Terry R. Myers

*Marc Camille Chaimowicz:
Celebration? Realife*
by Tom Holert

*Yvonne Rainer:
The Mind is a Muscle*
by Catherine Wood

*Fischli and Weiss:
The Way Things Go*
by Jeremy Millar

Andy Warhol: Blow Job
by Peter Gidal

Alighiero e Boetti: Mappa
by Luca Cerizza

Chris Marker: La Jetée
by Janet Harbord

*Hanne Darboven: Cultural
History 1880—1983*
by Dan Adler

Michael Snow: Wavelength
by Elizabeth Legge

Sarah Lucas: Au Naturel
by Amna Malik

*Richard Long:
A Line Made by Walking*
by Dieter Roelstraete

*Marcel Duchamp:
Étant donnés*
by Julian Jason Haladyn

General Idea: Imagevirus
by Gregg Bordowitz

*Dara Birnbaum:
Technology/
Transformation:
Wonder Woman*
by T.J. Demos

*Gordon Matta-Clark:
Conical Intersect*
by Bruce Jenkins

*Jeff Wall: Picture
for Women*
by David Campany

*Jeff Koons: One Ball Total
Equilibrium Tank*
by Michael Archer

*Richard Hamilton:
Swingeing London 67 (f)*
by Andrew Wilson

*Martha Rosler: The
Bowery in two inadequate
descriptive systems*
by Steve Edwards

*Dan Graham:
Rock My Religion*
by Kodwo Eshun

*Yayoi Kusama:
Infinity Mirror Room
— Phalli's Field*
by Jo Applin

*Michael Asher: Kunsthalle
Bern, 1992*
by Anne Rorimer

*Hélio Oiticica and
Neville D'Almeida:
Block-Experiments in
Cosmococa — program
in progress*
by Sabeth Buchmann and
Max Jorge Hinderer Cruz

Sanja Iveković
Triangle

Ruth Noack

My gratitude goes first and foremost to Sanja Iveković, whose work and feminist ethics have been an inspiration since my student days. She does not stand alone: I would like to acknowledge the friends and colleagues of Iveković, who provided her with intellectual and emotional sustenance over the years. They helped frame her work in a meaningful way, so that it could find new viewers, amongst them myself. If names are to be singled out from that group, they are Bojana Pejić and Dunja Blasević. Many people graciously shared their knowledge and helped me gather the facts: Zdenka Badovinac and Bojana Piškur of Moderna Galerija, Ljubljana; Daniela Zyman and Andrea Hofinger of TBA21, Vienna; Kasper König and Barbara Engelbach of Museum Ludwig, Cologne; Manolo Borja-Villel, Rosario Peiro and Concha Calvo Salanova of Museo Nacional Centro de Arte Reina Sofía, Madrid; Walter Seidl and Karolina Radenković of Kontakt, The Art Collection of Erste Bank Group, Vienna; and Sinisa Habus, Darko Fritz and Antonia Majača. Also thanks to Peter Weibel, Simonette Ferfoglia and Heiner Pichler. Antke Engel acted as sparring partner. Nataša Ilić, the manuscript's first reader, brought the inspiration and helpful criticism that got me to the finishing line. Throughout the research and writing process, Roger M. Buergel's intellectual dexterity proved invaluable. Cornelius, Barbara, Charlotte, Kasimir, Natascha, Susanna and Ebba generously let me take time off from family life, thank you. Anca, you were there for me. Last, but not least, there is a group of people who do not want to be named. For your insight, help and care, I thank you all – to quote Aby Warburg, 'God is in the details'. The editors would also like to thank Sanja Iveković for her invaluable help and generosity during the preparation and production of this book.

Ruth Noack is Head of Curating Contemporary Art at the Royal College of Art in London. Trained as a visual artist and an art historian, she has acted as art critic, university lecturer and exhibition-maker since the 1990s. She was Curator of documenta 12 (Kassel, 2007, with Roger M. Breugel as Artistic Director). Among other exhibitions she has curated with Buergel are 'Scenes of a Theory' (The Depot, Vienna, 1995), 'Things we don't understand' (Generali Foundation, Vienna,

2000), 'Organisational Forms' (Kunstraum Universität Lüneburg; Škuc, Ljubljana; Hochschule für Graphik, Leipzig; 2002–03) and 'The Government' (Witte de With, Rotterdam; MAC, Miami; Secession, Vienna; 2005). She provided 'Garden of Learning' (Busan Biennale, 2012) with its exhibition layout, and is presently working on a show called 'Sleeping with a vengeance – dreaming of a life'. Her reviews and monographic essays have appeared in numerous journals and catalogues.

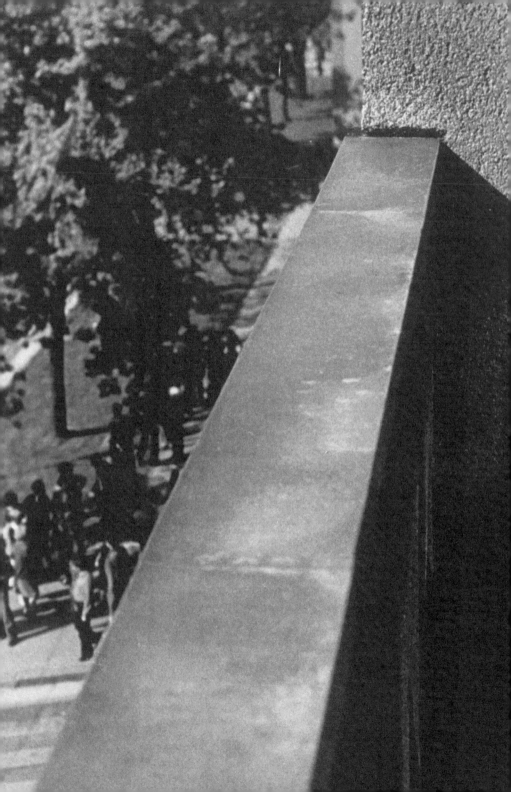

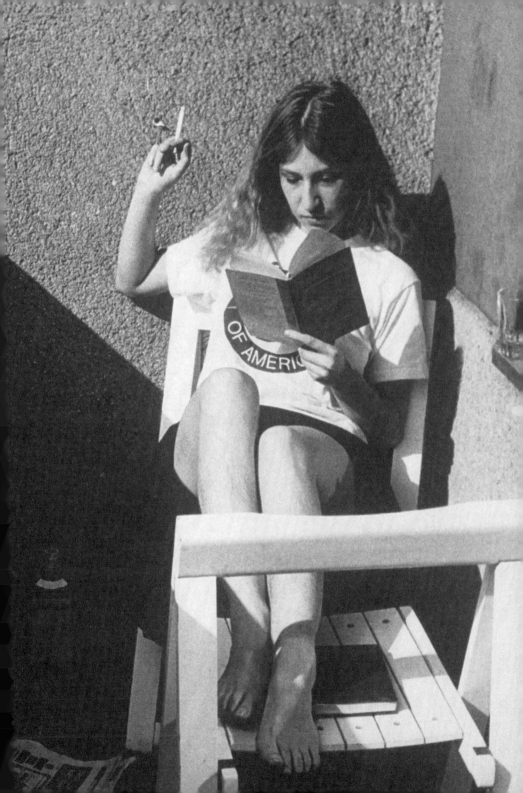

cover:
Sanja Iveković,
Trokut (Triangle), 1979,
four gelatin silver prints and text,
each photograph 30.5 × 40.4cm,
text 26 × 28cm,
detail

previous page:
Sanja Iveković,
Triangle 2000+, 1979,
four gelatin silver prints and text,
three photographs 30.5 × 40.4cm,
one photograph 40.4 × 30.5cm,
text 26 × 28cm,
detail
Courtesy Moderna Galerija, Ljubljana

For Charlotte

Contents

1 1. Taking on Tito: A *Mise en Scène*
10 2. To Be or Not To Be: A Canonisation
37 3. Putting it on Paper: A Diagenesis
43 4. New Art Practice in Yugoslavia: An Account
59 5. Democratisation of Art in Zagreb: A Problem
65 6. Taking Personal Responsibility: A Solution
72 7. An Artist's Work Is Never Done: A Poetics

89 Endnotes

One can rightfully say that those who were active on the
countercultural scene at the time took the socialist project
far more seriously than the cynical governing political elite.
— Sanja Iveković [1]

1. Taking on Tito: A *Mise en Scène*

'What to do about it?' This question posed itself to Sanja Iveković
when, in 1974, she found a leaflet in her mailbox, announcing
one of President Tito's frequent visits to Zagreb, and urging
those living in the city to participate in a public staging of
welcome (fig.3). The coercive nature of that particular practice
of citizenship, certainly not a new practice and certainly not
one specific to socialist statehood, must have irked the artist.
So much so that she went on to produce an ironic little work
titled *Spomenik* (*Monument*, 1979; fig.19), showing a group
of people doing their civic duty by their leader, all crammed
together on a small traffic island. The photograph's caption
reads: 'In memory of 88 comrades and comradesses who stood
on this particular spot in 1977.'[2]

Year in and year out, Iveković had the opportunity to observe
the grand parades from her balcony. Her apartment building,
the sort that we easily associate with late socialist modernism
(forgetting that buildings of this kind were brought to
Moscow by Le Corbusier), was located on Savska, one of the city's
new arteries, and therefore well situated for Tito-watching.
In 1979, five years after the leaflet arrived and the same year
as *Spomenik*, Iveković staged a performance. Not in a gallery
space, although the Students' Centre galleries, established in
the wake of the Yugoslavian student movement and a sign of both
its success and its failure,[3] had provided a suitable framework
for artists' performances throughout the decade. Nor did she
stage her performance in public, despite the fact that Iveković's
fellows in arms, the proponents of the New Art Practice in

Yugoslavia, had taken art to the streets once again, reaching back in some roundabout way to that historical moment of avant-garde utopia when art and life seemed to be in collusion. Iveković chose another setting, another *mise en scène* in which to act out her response: her balcony. Functioning as an in-between space, the balcony linked the privacy of the apartment with the outside world, in this case the urban environment, i.e. a space often taken to be synonymous with the public sphere.

Picture the scene: it is parade day again, 10 May 1979. The performance lasts 18 minutes, and this is how Iveković describes it:

> *The action takes place on the day of the President Tito's visit to the city, and it develops as intercommunication between three persons:*
>
> *1. a person on the roof of a tall building across the street of my apartment;*
> *2. myself, on the balcony;*
> *3. a policeman in the street in front of the house.*
>
> *Due to the cement construction of the balcony, only the person on the roof can actually see me and follow the action. My assumption is that this person has binoculars and a walkie-talkie apparatus. I notice that the policeman in the street also has a walkie-talkie. The action begins when I walk out onto the balcony and sit on a chair. I sip whiskey, read a book and make gestures as if I perform masturbation. After a period of time the policeman rings my doorbell and orders that 'the persons and objects are to be removed from the balcony'.*[4]

This account, together with four photographs taken at the scene, represents the performance today. From a number of possible materials, these five elements have been chosen by the artist and arranged into a form that has come to signify a work known, exhibited and collected as *Trokut* (*Triangle*, 1979; fig.1, 2, 12 and 13). It is through this photographic and textual installation that we relate back to the performance of 1979, and in return the past performance informs the work at hand. Thus, *Triangle* involves us, its present-day viewers, in interconnecting trajectories that are yet to be differentiated, triggered by the artefact on the wall and in some way relating to what must be considered significant traits of 1970s art practice, such as the dematerialisation of the art object and the structural treatment of visual imagery as a language system.

For if we were to look at *Triangle* as a performance, we would seek to place it within a context of agency, and therefore amongst forms of artistic expression that were both newly established and re-engaged with when artists tried, from the late 1960s onwards, to wrestle with institutions for the power of defining art. In other words, the discussion of *Triangle* within a history of performance art would foreground a discourse on artistic practices, be they avant-garde, neo-avant-garde or feminist.[5] If, on the other hand, we were to focus on the photographic installation of *Triangle*, the work would need to be contextualised amongst art practices proposing a critique of visuality, a category through which artists from the 1970s onwards attempted to look at ideology and subject formation. *Triangle* would then suggest a discourse that points beyond art's immanence, and towards an involvement in the social.

Ultimately, this distinction between *Triangle*'s two trajectories is somewhat rhetorical: matters are more complex. The performance has been understood by some as a political act

directed at the visual order of the socialist state.[6] If that is the case, it transgresses the borders of the art world, or at least aims to do so. Yet, the installation has been widely exhibited, reproduced and disseminated through catalogues and other publications. It has been introduced into collections and canons of art. The work thus also gravitates towards an art context. But even if civil society and the art world were to be clearly set apart, art practices cannot necessarily be made to adhere to the same division — just as the performance and the photographic installation of *Triangle* cannot be neatly separated. At some point in this text, the status of their alliance will need to be discussed. For the moment, it might suffice to call to mind the fact that many artists working in performance in the 1970s made frequent use of other media, without much interest in creating hierarchical order amongst their different practices, or attaching preordained meanings to one medium or another.[7] Maybe this is just an effect of modernism's demise, although what looks like a sudden freedom from the restraints of media purity might simply have been due to a change in regime. After all, Conceptual art and what was then called 'media art' came with their own set of restrictions, styles or looks. We know this in hindsight; still, the negation of medium specificity did, at first, open up new possibilities of artistic expression.

The important point is that the question of how to situate their work politically seemed, once again, urgent to artists like Sanja Iveković, and thus my hasty identification of opposing trajectories within *Triangle*, one geared toward the sociopolitical and the other dealing with form, is not completely off target. These trajectories are not particular to *Triangle*, not even specific to Iveković's oeuvre, although they certainly seem to be driving her work, and they undoubtedly had particular resonance in her geo-political context. 'Yugoslavia', writes curator Ana Janevski, 'was particularly interesting as a cultural space in which parts

of the communist political and cultural elite recognised correspondences between the universalism of modernist art and the universalism of socialist emancipation.'[8] Let's turn the clock slightly forward, to Iveković herself, speaking on the New Art Practice, the conceptually oriented Yugoslavian art movement of the 1970s: 'The paradox is that we as artists had serious intentions of "democratising art" but the artistic language that we were using was so radically new that our audience was really limited.'[9]

But I am getting ahead of myself, pulled into history by *Triangle*'s unstable condition as a depiction of and reference to a performance that happened over thirty years ago, instead of confronting the photographic installation itself, which is present and needs to be addressed. The four individually mounted photographs of equal size are arranged in a geometrical pattern, part of an imaginary grid. All four photographs are shot from Iveković's balcony and three of them, arranged in a column, depict the parade from different perspectives. The centre is occupied by a photograph of Tito's car passing in a motorcade through the street filled with people. Above it sits an image of the building across the street, a hotel; on its roof, a tiny human figure. And in the photograph underneath we are shown the crowd milling along Savska Street, partially obscured by a Yugoslav flag. The fourth photograph, adjoining the others to the right, displays Sanja Iveković on her balcony. She is lounging, reading T.B. Bottomore's *Elites and Society* (1964).[10]

This intimate close-up of Iveković counterposes the wide-shot depiction of Tito, and it is hard not to read into the agonistic coupling. Here the male statesman, in a populist projection of his self onto the public; there the female artist, inwardly focused, engaged in intellectual pursuit. Judging by the surrounding paraphernalia, she is not only introjecting food for thought,

but also drinking and smoking. She is not depicted masturbating. Although her skirt is slightly pushed upwards and her hand rests on naked skin, the gesture is far from obvious. To be sure, it is personal, but in an informal setting such as this it might also be read as a form of unconscious self-containment, something that one does in private when concentrating on reading a difficult text.[11] The gesture underscores the general impression that the photograph is a snapshot, although a closer look at its composition raises doubt. The composition is carefully balanced, to the extent that the photographer has managed to include a fragment of the street that places the balcony at the scene of the crime. Although we cannot be sure, we can easily imagine that the people we see are attending the parade depicted on the neighbouring photograph.

If the private scene portrays the artist surrounded by props of sustenance, the rendering of Tito uncovers another kind of dependency on props. In order for the statesman's public persona to appear, it needs a blown-up apparatus, so unwieldy that Iveković does not seem able to contain it in one image — it bleeds over into three. In its more benign form, the apparatus is signified by the choreography of the motorcade, with rather trite modernist metaphors of speed and progress, enacted by phallic cars and a generous sprinkling of attending motorcycles. Rather less benign is the fact that the police or military are acting out the state's executive might, as citizens are seen performing the stationary body, through which the governmental force is moving. Both identification and control play their parts in the grand scheme of symbolisation. Finally, yet another aspect of the state's apparatus is revealed: the naturalising power of mass media.[12] Iveković cites media images in *Triangle*'s perfect shot of Tito passing in his car, and thus suggests that the purpose of the motorcade is partly to provide a photo-opportunity, recycling images that have become all pervasive. (One such

newspaper image was collected by Iveković and turned into the work *Novi Zagreb (Ljudi iza prozora)* (*New Zagreb (People Behind Windows)*), 1979; fig.20).

The battle between the photographs of Tito and Iveković is not merely waged between a man in public office and a woman whose status as avant-garde artist yields her only a very limited public role.[13] The confrontational mode does not, at first sight, allow for subtleties. On the contrary, the argument is a rather polemical one, asking us to compare and contrast several dichotomies along the axis of power relations: man/woman, politician/artist, public/private, media image/snapshot... This method of argumentative juxtaposition was not new to Sanja Iveković. Whether through a critique of the lack of visibility of women artists from Yugoslavia on an international platform (*Women in Art — žene u jugoslavenskoj umjetnosti* or *Women in Art — Women in Yugoslavian Art*, 1975; fig.16) or a study of the effects of mass media on an individual's identification as feminine (*Dvostruki život*, or *Double Life*, 1975; fig.17), Iveković had already asked viewers to consider one or several pairs of images in order to draw conclusions based on their differences and similarities.

Yet *Triangle* consists of more than two images. Though I have argued that the top and bottom photographs bracketing the central image are basically extensions of it, there are some deviations that need to be heeded. The epic framing of the central image suggests at once that this is an important historical moment and that the image is a slice of life. In other words, the unity of time is not called into question by this picture, though it is, like every photograph, showing a particular moment in time, and as such it might theoretically be a threat to continuity. This threat, however, is contained by the balanced composition, which allows the viewer to phantasmatically see the cars proceed at an even pace along their path. In contrast,

the framings of both the photograph of the hotel and the shot onto
Savska Street disrupt the time-space continuum. The photographs
are awkwardly cropped, in a manner that fragments the images.
Even the flag is weirdly cut off at the top; instead of signifying
the unity of the nation, it has become a somewhat strange,
slightly bothersome object, obscuring the spectator's view onto
the street. Moreover, the obvious tilt of both photographs
emphasises a subjective point of view. This askance composition
is obviously not Iveković's invention; it finds its easy predecessor
in the avant-garde photography of Alexander Rodchenko and
the likes. However, the haphazardness of the framing (or shall
we call it the slight sloppiness of the shots — notice also the
overexposure of the top photograph) does not fit the historical
model, which constructed its visual field with the utmost
precision. This indicates that the avant-garde tradition is
known but not directly adhered to. *Triangle* is produced in a
cultural context in which a watered-down version of the avant-
garde vocabulary has been preserved and kept alive in everyday
design. But I get ahead of myself again — there is further
information or intelligence to be culled from the top and
bottom photographs.

For what can it mean, this discrepancy in the three photographs
of Tito's parade, one being posed as an objective image, and the
other two as subjective points of view? It is strange, since the
images all come from the same source,[14] and were presumably
shot consecutively. I presume this not because the photographs
themselves give me much evidence. Rather, I am prepared
to follow Sanja Iveković in her description of what this is
evidence of. For the moment, I accept that these photographs are
more than a representation of the performance — they are its
documentation.[15] Nevertheless, they remain an ambiguous set of
documentary images, exhibiting different attitudes towards the
depiction of reality. Why this ambiguity? Beyond the deduction

that such a switch of perspective requires a reflexive, even self-reflexive approach, we might also come to the conclusion that there is reason at work.

By taking a subjective point of view, Iveković is claiming the two scenes as effects of her own sight, while at the same time distancing herself from the official version of the parade. Because she is seeing the man on the hotel rooftop and the people in the street, they become visible as those aspects of the state's apparatus that operate exactly through invisibility. Most of the time, the state's executive functions as a threat that does not need to be executed (and thus materialise) in order to be effective. We see the uniform and know what it means, but the violence it potentially signifies is not manifest. Most of the time, the state's legitimation functions on a naturalised idea of its public formed by its citizens. We see the unity of the public, guaranteed in the photograph of Savska Street by the flag and a row of policemen, who are delimiting the crowd, but its exclusions and cost to the individual are not acknowledged by the image.[16] In the case of *Triangle*, the manoeuvre of the artist allows these ideas to appear in the field of visibility. And it binds them, via the subjective angle, to the artist herself. 'I see (the truth), therefore I am (artist).' The triangle, defined in the description of the performance as as a three-way communication between the artist, the man on the roof and the policeman on the street, is also a triangle of sight.

In the installation, this is transposed into a formal figure: the three images based on a subjective point of view are arranged according to a triangle. Moreover, though the artist herself does not look up, busy as she is with whatever she is doing — reading the Marxist treatise on elites and democracy? Masturbating? Drinking and smoking? Trying to look as if posing for a photograph is fun? — we can establish her line of

sight. All three photographs have compositions that stop the viewer's eye in its inclination to transgress beyond the points of the triangle and thrust it back into the mix. This is why the slanted line of the balcony's railing, which prefigures Iveković's reclining body, giving it the support of a visual analogy while also delimiting her space as separate (if not autonomous) from the parade, is so important. We encounter the railing again in the lower left corner of the photograph of Savska Street, playing a similar function, although this time it is vaguely aligned to another shape, the flag. Finally, the trio of boundaries is completed by the photograph of the hotel across the street. Here, the slanting of the edifice is doubled by a striking and stark black shadow, filling the upper left corner, thus corresponding with the composition of the railing on the bottom. So what if Tito's car were to continue its trajectory towards the left edge of the picture and vanish out of sight? Nothing to stop him, nothing to stop the machine of socialist progress... Would it be missed by the viewer who is busy bouncing (or rather being bounced) back and forth between the other three images?

2. To Be or Not To Be: A Canonisation

In 2007, when *Triangle* was installed at documenta 12, Roger M. Buergel and I were unaware of Sanja Iveković's specifications for its display.[17] The work had previously appeared in a variety of formats in books and catalogues, and we incorrectly assumed that the arrangement of photographs and text was at our disposition. Installing is all about composition. In a flight of curatorial fancy, we placed the four photographs and the text in an El Lissitzky-esque manner (fig.11), trying to strike a balance between potential dispersal and potential implosion. I even imagined that the artist would be tickled by the reference. She was not. A day into the exhibition, we received a specific set of instructions according to which the work was to be rehung immediately. Needless to say,

we complied (fig.12). At the time, I accepted the artist's wishes without giving much thought to her motivation. If I had, I would most probably have believed her directive to be a symptom for the need to take at least some control in what was, after all, an overwhelming situation for everyone involved in producing this large-scale exhibition.

Back in 2007, it did not occur to me that *Triangle* might consist of more than its five material elements, nor that its argument might rest on its form of installation. Today, my reading makes use of the display as an established factor of the work. Then, the instructions asked only for the four photographs to be hung in a particular relation to each other. Today, the work comes with a drawing rigorously detailing the spacing, including the placement of the text, 'since', Iveković writes, 'I found that the curators do the display as they please'.[18] Then, the text was photocopied or printed out in any font on the occasion of the exhibition. Today, it is an editioned object framed in the same manner as the photographs.[19]

What happened between then and now? An easy answer is: canonisation. *Triangle*'s exhibition history has multiplied in the past decade,[20] spurred on by the rediscovery of the former East European neo-avant-garde by the art world of the former West.[21] Between 2003 and 2011, all five copies of the edition of *Triangle* have been acquired by major collections.[22] An earlier version, *Triangle 2000+* (1979; fig.9 and 10), was sold to Moderna Galerija in Ljubljana in 2000. Paradoxically, as the artist gains recognition she loses control over the work, either through change in ownership or because she cannot be directly involved in each and every presentation of it. In this respect, the fixing of the display seems a pragmatic response to altered circumstances — an artist protecting her work from a certain degree of curatorial debasement.

In 2008, in an interview with Iveković, Antonia Majača raised the question of whether Eastern European feminist Conceptual practices were 'returning' to the Western map as 'commodified art practice within late capitalism', and whether the paltry introduction of a handful of Eastern female artists into Western group shows served 'a quota of political correctness'.[23] This was a leading question, which, in Iveković's case, is countermanded by the fact that the artist has had four large-scale retrospectives in Western Europe and the US in a period of ten years.[24] But still, the question is an interesting one. It needs to be qualified, though, because the category 'Eastern European feminist Conceptual practice' wrongly hints at a movement, which did not exist at the time. For the term 'feminist' implies a concerted politics, rather than a number of individual artistic attitudes, and there is no evidence of an Eastern coalition between artists and feminists. In fact, feminist discourse in Yugoslavia saw visual art — when it saw it — as *nebenwiderspruch* (an irrelevant side contradiction),[25] to use the Marxist term appropriate to the time. Neither did the New Art Practice recognise the issue. As Iveković has explained,

> As there were no feminist artists or critics on the scene, local critics (male, of course) understood my work as (only) an auto-referential attitude; an analysis of the 'institution of the artist', which was a popular subject for Conceptual artists. The critical apparatus for a different reading of these works simply did not exist.[26]

Before the blame for this absence of a critical feminist art discourse is laid at the wrong doorsteps, let me hasten to add that historical circumstances made it particularly difficult to grasp sexism in Yugoslavia, i.e. to recognise, understand and articulate it. For gender equality was written into the law since the beginning of the socialist state, after a revolution that had,

to a substantial degree, been carried out by women.[27] At the time, Yugoslavia had one of the most advanced abortion policies within Europe; social security, childcare and paid maternity leave were also in place. Moreover, public discourse proclaimed a genderless society,[28] and when the need for further women's emancipation was admitted to, the problem was thought to be subsumable under the wider issue of class struggle.[29] The workplace had absolute centrality. It was the stage for any social change. Domestic violence, unpaid reproductive labour[30] and the sexism that came with increasing consumerism and its correlate, the advertisement industry, were relegated to a private sphere that was neither to be looked at nor spoken about.[31]

With this historical background in mind, we must ask ourselves why Majača uses a category such as 'Eastern European feminist Conceptual practices' at all? The answer is obvious: the stakes are high as to who gets to define the terms for narrating Yugoslavian art history of the 1970s, and much in this struggle — for it still is a struggle, as a large portion of this history is yet to be written — is governed by two sets of power relations, those between the former West and former East and those between men and women. Majača's question aims at the first conflict, and it does not leave us guessing as to who is perceived to be winning: the West. Interestingly, Sanja Iveković responds to the question with a shift. From the start, she does not seem to accept the premise that the problem of art's incorporation into an art system can be reduced to a dichotomy between East and West. Instead, she initially ties the issue back into a Western feminist discourse on institutionalisation:

> *I agree with Linda Nochlin that it is difficult (I would say almost impossible) to transform a life experience of feminism and feminist art practice into a historical text. [...] This is, of course, followed by a tendency to idealise the past, so that,*

in spite of it consisting of numerous and often contradictory forms (this is especially true of the American scene), early feminist art is portrayed as a homogeneous body of work.[32]

In a second step, she localises this discourse within US hegemony, and then criticises it for its own blind spots *vis-à-vis* Eastern European art by women. Finally, she points out the existence of specific practices across the East-West divide with a potentially more complex perspective. She thus elegantly diverts the focus of attention from herself — and who, if not she, would be included in the category 'Eastern European feminist Conceptual practice'? — towards an enquiry into the coordinates that govern the game of appearance. I am convinced that it is this ability to transgress pre-formed Conceptual borders without losing sight of the permeating power structure that has made Iveković such a central figure for her contemporaries and for a younger generation of artists, curators and art historians in both East and West.

Canonisation is not simply of a work of art but of an artistic practice, which is thought by a larger group of people to be significant in terms of its ideas, its politics and the peculiar knowledge it brings forward. *Triangle* has become a canonical work not only because it has been introduced into major public and private collections, but because people have, for diverse and not all insincere reasons, attached themselves to it. The manner in which this has happened must be further explored, not because I expect to uncover in the circumstances of this particular canonisation new knowledge as to how such processes transpire. My concern is that the story of the 'making of' *Triangle* contains the transformation of a performance into an installation as well as its canonisation — and somehow those two threads are intertwined. To put it bluntly: are we to address the genesis of *Triangle* solely within the art historical parameters of

materialisation, or do we have to ask ourselves whether the form in which the performance presents itself to us today was somehow a result of the mode of its art-historical appearance? I have argued above that some parameters of the installation are the result of the latter. Are there other ways in which materialisation and canonisation are connected?

In December 1980, a year after *Triangle* was enacted, Sanja Iveković displayed its documentation in an exhibition featuring performance work she had done between 1976 and 1979. Though we have no images of this show, a publication survives, the first printed visual depiction of the performance.[33] Only the description, in Serbo-Croatian and English, and three of the photographs are published; the image of Tito passing by is missing (fig.7).[34] When asked about it, Iveković responded: 'I do not remember what happened, but I guess the graphic designer (and curator) made the choice!? Even I don't remember if I reacted to this, most possibly I expected it. Self-censorship was the most powerful institution in our socialism.'[35] This speculation sounds plausible, as critical depictions of Tito were one of the areas where censorship was to be expected in socialist Yugoslavia. And why else would the curator have refrained from even referring to the work in his otherwise all-encompassing introductory essay?[36] In retrospect this silence seems rather strange.

Almost twenty years went by without another showing. For the most part this was due to Iveković's change in focus, which corresponded with an international shift towards a new media paradigm: Iveković increasingly exhibited video work. For every presentation in Zagreb, she was participating in around three shows elsewhere. The discovery, during the past decade, of *Triangle* as a seminal work of the 1970s follows a larger trend in the West to reappraise political Conceptualism.[37]

In comparison, the Eastern reappearance of the work in 1998 is attributable to two simple causes. Firstly, Iveković had been invited to participate in Manifesta 2, and on this occasion she received public funding to produce a catalogue of previous work, *Sanja Iveković: Is This My True Face* (1998).[38] The book contains Bojana Pejić's feminist essay 'Metonymical Moves', which offers one of the earliest decisive interpretations of Iveković's performance. Secondly, the documentation of *Triangle* was shown at Moderna Galerija in Ljubljana in the exhibition 'Body and the East' (1998; fig.8), which set out to make a canon of Body art and performance from Eastern Europe, informed by — but in deliberate emancipation from — hegemonic Western discourses concerning art.[39] Two years later, Moderna Galerija, aiming at the time to become the leading museum of Eastern European contemporary art, acquired for its Arteast 2000+ collection the version of the work that came to be titled *Triangle 2000+* (fig.10).[40]

Triangle's exegesis by Bojana Pejić and its introduction into a canon of Eastern European Contemporary Art proved to be formative for the work's contemporary reception. On the one hand, there now existed an artwork that could travel independently of the artist's assertion of its status, propped up by the legitimising power of a museum. On the other, the artwork came with a comprehensive interpretation — one extremely attractive to curators and critics at the time. Pejić's essay included charged sentences, such as '*Triangle* is a performance "about" the *liaison dangereuse* between sight and power, between *voir* and *pouvoir*.'[41] Crucial to the appeal of Pejić's text, and subsequently the work, was the fact that it allowed people to recognise the universal (feminist analysis of power) in the locally and historically specific (socialist Yugoslavia). Thus the work could serve as a vehicle of translation between past and present and East and West, at a time when many had

lost the means to make sense of a globalised but fragmented world. It told a story that we wanted (and needed) to hear.

Yet, however brilliant, Pejić's interpretation is based almost exclusively on the narrative of the performance. It takes the photographic installation into account solely as a source of iconography. This is actually in keeping with the idea that these materials are purely documentary, as they might have been when Pejić was writing. But by the time *Triangle* entered the collection of Moderna Galerija, conditions had changed — the installation had become a work. Since then, the uncritical appropriation of Pejić's reading has led to a curious dissociation between what we actually get to see (images and text in a particular visual form) and what we are meant to be seeing (performance). I would argue that this dissociation manifests itself as a symptom, a certain blindness regarding the work: there are obvious differences in the diverse (re)presentations of the work, which no one seems to have noticed, nor wants to be bothered with. There is some variance in the cropping and exposure of the prints. Some show more detail than others, such as seven policemen instead of just three walking the street (fig.6); Iveković appears with an ashtray and a whiskey glass, or neither; or the black shadow I referred to above as running along the left side of the photo-graph with the hotel building is cut (fig.5). The most apparent disparity lies in the use of three different depictions of the balcony scene (fig.4). In two cases, Iveković is figured holding a cigarette in one hand and a book in the other, while only in the photograph used for the main edition of *Triangle* has she placed her hand into her lap. If the three photographs were put next to one another, the increasing recline of her body would be quite suggestive. However, they have never been shown together; and in fact they stand in for each other, as if they were one and the same.[42]

'I have found that aesthetics are inseparable from politics',
Sanja Iveković has said. I agree. Yet there is in the discussion of
Triangle produced until now no discourse on Iveković's aesthetics,
and therefore the question arises as to what we are to do about
the variances in *Triangle*, which apparently come to light only
when we look at Iveković's work with an analysis of form in
mind. Precisely because aesthetics are not inseparable from
politics, I cannot disregard the formal aspects of the work that
others seem to have deemed irrelevant. But how to read them?
At the same time, I cannot but wonder: isn't it rather obvious
that the existence of aesthetic discourse or lack thereof must
be attributed to something other than the inherent features
of an artwork? There certainly are contexts in which reference
to the formal aspects of a work does not discredit its political
character, whereas in others there does not even seem to be a
language with which to start. Isn't it the case that hegemonic
art contexts have less trouble discussing aesthetics with
politics and politics with aesthetics than communities that
are marginalised? Whether by choice or through inequity,
those communities deprived of power more often than not seem
to deal in pure politicality. While this frees the others to reflect
upon aesthetics *as* a politics, one should not lose sight of the
fact that this discourse also comes with an inherent bias —
or privilege — and that, when all is said and done, society as
a whole needs to take on responsibility for the essentialism of
its marginalised communities.

Imagine the political climate in which a certain discussion
of aesthetics is supposed to take place:

> *During the 1990s, with Croatian society contaminated by*
> *nationalistic ideology, war, the triumph of capitalism and*
> *the rediscovery of market economy, the struggle against*
> *what was denounced as the Left's cultural hegemony, now*

Sanja Iveković,
Trokut (Triangle), 1979,
Performance / photographs
Time: 18 min

The action takes place on the day of the President Tito's visit to the city,
and it develops as intercommunication between three persons:

1. a person on the roof of a tall building across the street of my apartment;
2. myself, on the balcony;
3. a policeman in the street in front of the house.

Due to the cement construction of the balcony, only the person on the roof can
actually see me and follow the action. My assumption is that this person has
binoculars and a walkie-talkie apparatus. I notice that the policeman in the
street also has a walkie-talkie. The action begins when I walk out onto the
balcony and sit on a chair. I sip whiskey, read a book and make gestures as if
I perform masturbation. After a period of time the policeman rings my doorbell
and orders that 'the persons and objects are to be removed from the balcony'.

Savska 1
Zagreb, 10 May 1979

1—2. This page and the following
double page spread:
Sanja Iveković,
Trokut (Triangle), 1979,
four gelatin silver prints and text,
each photograph 30.5 × 40.4cm,
text 26 × 28cm

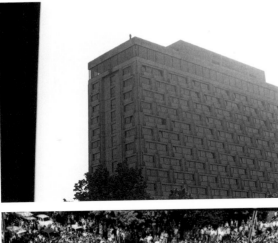

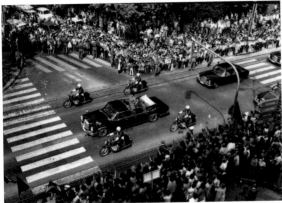

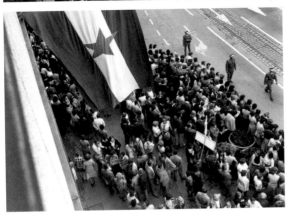

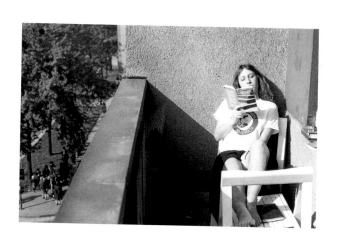

3. Original leaflet from 1974.
The text translates as:

'Notice

Tomorrow, on Saturday 13.7.1974, at 6 p.m.
our dearest guest Comrade Tito, President
of the Republic and of the Communist Party
of Yugoslavia, is coming to our city.

We call on all the citizens of this community
to turn out in large numbers to welcome
our dear guest and wish him a pleasant stay
in our city and his.

Citizens of this district shall be organised
in Ilica Street, from Vodovodna Street to
Selska Street. Going to the gathering place
is to be done individually by tram number
11. One should reach the determined place
by 5.30 p.m. at the latest as after that time
the traffic will be closed down.

Social and political organisations and
the council of the local community'

O B A V I J E S T

SUTRA U SUBOTU 13. 7. 1974. U 18 ČASOVA DOLAZI U NAŠ GRAD

NAŠ NAJDRAŽI GOST, PREDSJEDNIK REPUBLIKE I S. K. J. DRUG T I T O.

POZIVAMO GRADJANE NAŠE MJESNE ZAJEDNICE DA U ŠTO VEĆEM

BROJU IZADJU NA DOČEK DRAGOG NAM GOSTA I DA MU ZAŽELE UGODAN

BORAVAK U NAŠEM I NJEGOVOM GRADU.

GRADJANI NAŠE OPĆINE BITI ĆE RASPOREDJENI U I L I C I NA

PROSTORU OD VODOVODNE ULICE DO SELSKE CESTE. ODLAZAK DO MJESTA

PRIKUPLJANJA VRŠI SE INDIVIDUALNO TRAMVAJEM BROJ 11. NA ODREDJENOM

MJESTU TREBA BITI NAJKASNIJE DO 17, 30 ČASOVA JER SE POSLIJE TOG

VREMENA ZATVARA PROMET.

DRUŠTVENO POLITIČKE ORGANIZACIJE
I SAVJET MJESNE ZAJEDNICE

4. Three different versions of the photograph of the balcony. The top photograph is not part of any edition of the work but was published in *Sanja Iveković: Performans/instalacija*, Zagreb: Studio Galerije Suvremene Umjetnosti, 1980.

The middle photograph, showing the raised right hand holding a cigarette, is now part of *Triangle 2000+* (1979).

The bottom photograph is from *Triangle* and is the version most often used in the various editions of the work.

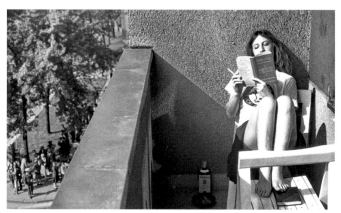

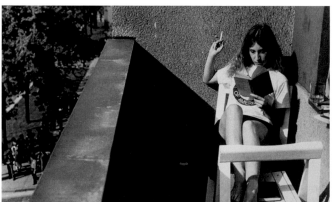

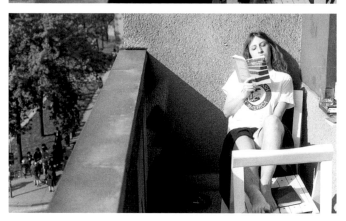

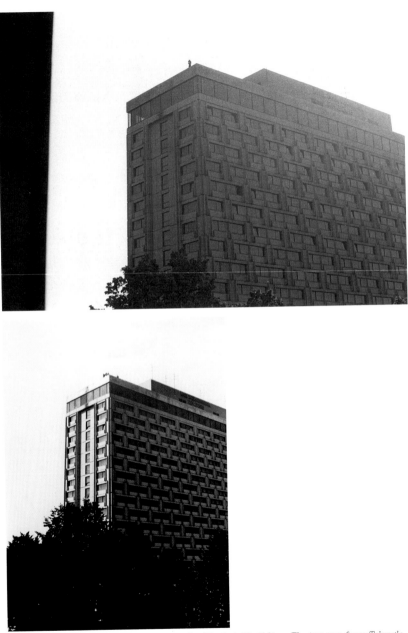

5. Two different versions of the photograph of the hotel building. The top one, from *Triangle*, shows one person on the roof, and the bottom one, from *Triangle 2000+*, shows four people on the roof.

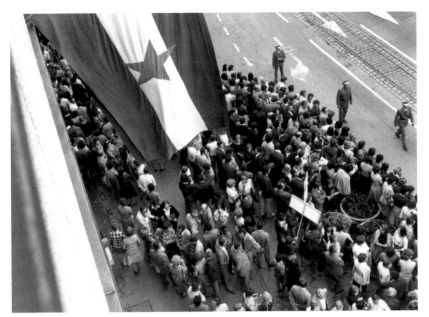

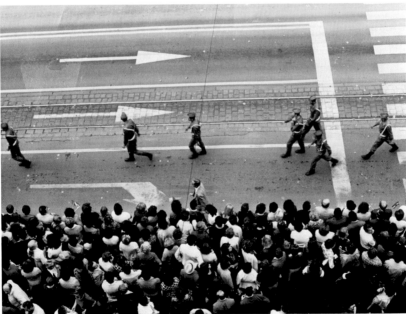

6. Two different versions of the photograph of the crowd.
The top one is a detail from *Triangle* and the bottom from *Triangle 2000+*.

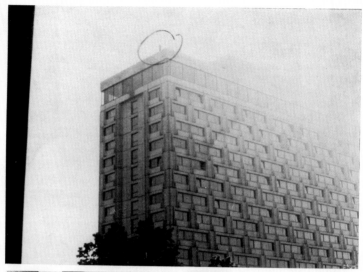

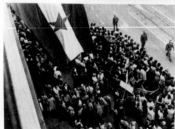

Trokut

vrijeme: 18 min.

Akcija se događa na dan kad je najavljen dolazak Predsjednika u grad, a u njoj sudjeluju tri osobe:
1) osobe koja je na krovu hotela koji se nalazi preko puta zgrade u kojoj stanujem,
2) čuvara reda koji se nalazi na ulici ispred zgrade
3) i mene na balkonu zgrade.
Zahvaljujući betonskoj ogradi balkona samo osoba na krovu može vidjeti i pratiti akciju. Pretpostavljam da ta osoba ima dalekozor i voki-toki uređaj, pomoću kojeg može stupiti u kontakt sa čuvarima reda na ulici.
Akcija započinje mojim izlaskom na balkon. Iznosim dvije stolice, bocu whiskeya, cigarete, knjige. Sjedim, pijem, pušim i čitam. Zatim zadižem suknju i činim geste kao da masturbiram. Nakon nekog vremena zvoni zvono na vratima mog stana i preko kućnog telefona osoba koja se identificira kao službeno lice naređuje da se »uklone sve osobe i stvari sa balkona«. Time je akcija završena.

Savska 1
Zagreb, 10. svibnja, 1979.

Triangle

time: 18 min

The action takes place on the day of the President's visit to the city. It develops as intercommunication between three persons:
1 a person on the roof of the high building which is across the street of my apartment,
2 myself on the balcony
3 a policeman on the street n front of the house.
Due to the cement construction of the balcony only the person on the roof can actually see me and follow the action. My presumtion is that this person has a fieldglass and the walkie-talkie apparatus. I also notice that the policemen on the street has one walkie-talkie.
The action begins when I walk out on the balcony and sit on the chair. I drink whiskey, read the book and perform masturbation. After some time a policeman rings on my dorbell and orders that "persons and objects should be removed from the balcony".

Savska 1
Zagreb, May 10, 1979.

7. *Triangle* as reproduced in *Sanja Iveković: Performans/instalacija*, Zagreb: Studio Galerije Suvremene Umjetnosti, 1980

8. *Triangle* as reproduced in the exhibition
catalogue for 'Body and the East',
Moderna Galerija, Ljubljana, 1998
Courtesy Moderna Galerija, Ljubljana

9. Sanja Iveković,
Triangle, 1979,
installation view,
'Arteast 2000+. The Art of Eastern Europe
in Dialogue with the West',
Museum of Contemporary Art Metelkova,
Ljubljana, 2000
Courtesy Moderna Galerija, Ljubljana
Photograph: Lado Mlekuž and Matija
Pavlovec

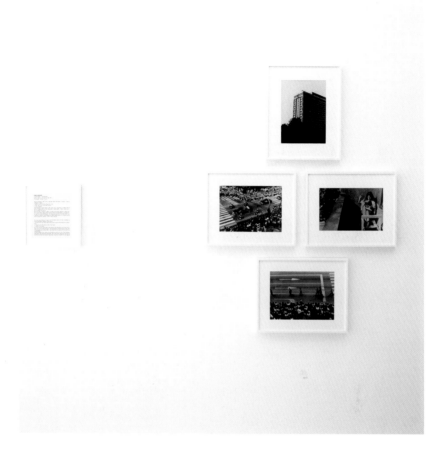

10. Sanja Iveković,
Triangle 2000+, 1979,
installation view, 'Museum of Affects',
Museum of Contemporary Art Metelkova,
Ljubljana, 2011
Courtesy Moderna Galerija, Ljubljana
Photograph: Dejan Habicht

11. Sanja Iveković,
Triangle, 1979,
initial installation at documenta 12,
Kassel, 2007
Photograph: Roger M. Buergel

12. Sanja Iveković,
Triangle, 1979,
revised installation at documenta 12, Kassel,
2007
© Egbert Trogemann, DACS London
Photograph: Egbert Trogemann

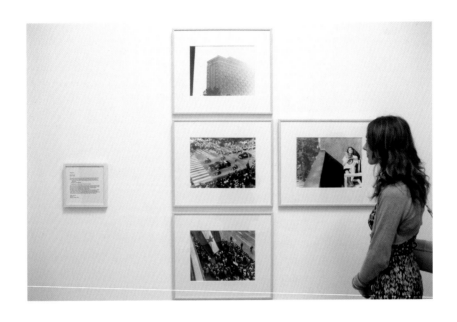

13. Sanja Iveković,
Triangle, 1979,
installation view, 'Sanja Iveković:
Practice Makes the Master',
Muzeum Sztuki, Łódź, 2009
Photograph: Piotr Tomezyk

understood as a foreign element that threatened the purity of national identity, officially accepted the Left's anti-fascist heritage, but in practice denied it by supporting an amnesia about the whole socialist era.[43]

I cite this sentence from an essay on Sanja Iveković by Nataša Ilić and Dejan Kršić not because I hope to sum up with one single stroke what is an incredibly complex political and cultural situation, but in order to illustrate part of the backdrop against which the canonisation of *Triangle* took place. From a former East perspective, there is more to be taken into account than the process of integration of a local neo-avant-garde into a post-communist art world. It seems reasonable to me that one would try to retain (or gain) the political over the aesthetic, if the threat were historical decontextualisation, followed by art market aestheticisation. And there are instances when this threat is realised.[44]

At other times, the political appears in an exhibition as a prevalent curatorial category, yet is defined in such a way that the politics of an artistic practice like Iveković's, which is so much concerned with feminist forms of production and communication, remain unrealised. Take, for example, the momentous 'WACK!: Art and the Feminist Revolution' (2007—09), the first mainstream exhibition of art by women from a feminist perspective to happen in decades.[45] It included a considerable amount of work by non-US artists at the expense of reaffirming the erroneous notion that North American feminist practice somehow predominated the international scene.[46] Take another major feminist exhibition, one closer to Iveković's heart, 'Gender Check: Femininity and Masculinity in the Art of Eastern Europe' (2009).[47] Its vast wealth of contextual knowledge, based on in-depth original research, was made available in printed matter but not carried into the exhibition

proper. The comprehensive exhibition, surveying over fifty years of gender in the socialist iconosphere, proved very exciting to its audience and art historians, who had never seen this kind of work appear with such force in the public sphere. But it also conformed to a cultural studies taxonomy,[48] with the result that very different kinds of art were made 'the same'.[49] Even though neither 'WACK!' nor 'Gender Check' were deterministic or essentialist, both exhibitions are examples of the difficulties that arise in showing artwork originating from a site of double exclusion (due to gender and geography) under conditions of appearance determined by paradigms of the Western patriarchy.

Which all goes to show that those who write about or exhibit an artwork are heavily obliged to reflect their participation in the 'making (visible) of' said work. Thus my commitment to a close formal reading: I hope to arrive at the politics of *Triangle* through its form. Before I continue in this vein, one earlier thought needs to be expanded. Canonisation affects work and artist in diverging (and ambivalent) ways: on the one hand a piece is taken care of, interpreted, made visible to a larger audience; on the other it is cut off from potential meanings, functions, publics. An artist might gain agency through canonisation and at the same time lose the power to determine the meaning of this. In the case of *Triangle*, this ambivalence might be compounded by the fact that this work was made by a woman at the end of the 1970s in Zagreb. Yet the ambivalence of canonisation as such is a known factor; it has been reflected upon by artists and philosophers at least since Marcel Duchamp displayed his *Fountain* (1917), and it has informed, both aesthetically and strategically, the practice of countless conceptual artists since.[50]

3. Putting it on Paper: A Diagenesis

But I am also ready to fight for a visual language of my own...
— Sanja Iveković [51]

Somewhere on the way from performance to photographic installation, canonisation set in and muddied the waters. A number of strategies, in particular the dictating of a rigid matrix for the installation, were developed in response to this. That we know. Which is not to say that the photographic installation of *Triangle* would have looked different had it been less exposed — it might have sedimented in this same way. 'Sedimentation' is a good expression here, because the visual evidence suggests a process in time, it points to gestation, rather than a one-time act of fixing upon a form. 'Visual evidence' means the wealth of visual manifestations of *Triangle*: the copies of the work provided by today's owners, the installation shots and finally the manifold reproductions in exhibition catalogues and art history books. Through those catalogues and books the work has been widely disseminated, as some of them have themselves become part of an art historical canon. They contain representations of *Triangle* that jump all over the place. Early examples feature only three images plus text, though not the same three (fig.7 and 8);[52] later the work appears as four varied photographs with or without text. Most confusing are those instances in which photographs from different editions are combined. This makes the timeline for the actual fixing of the editions uncertain, though all sources date them from 1979. In an essay by Pejić from 2002, the Moderna Galerija's shot of Iveković on the balcony, from *Triangle 2000+*, is printed together with photographs from a final edition copy, and a similar composite appears as late as 2009, when the edition had long entered collections, in the English translation of

Piotr Piotrowski's *In the Shadow of Yalta: Art and the Avant-Garde in Eastern Europe, 1945—1989.*[53] Since I cannot imagine that the authors and graphic designers were purposely mixing and matching, I venture the guess that images for reproduction originated from the artist's studio.

Clearly, Iveković did not (or was not able to) control the arrangement of the photographs on the printed page. Compositions vary without discernible continuity.[54] An early reproduction approximates the final work, displaying the column of three photographs with a much smaller image of Iveković on the balcony placed next to the Tito parade.[55] But it is not until the exhibition catalogue of the retrospective organised by Göteborgs Konsthall, Gothenburg; Kölnischer Kunstverein, Cologne; and Fundació Antoni Tapiès, Barcelona in 2008 that reproductions are in line with the final composition and proportions of the photographic installation.[56] The first installation view of *Triangle* following this arrangement was taken at Galerije Galženica in Zagreb in 2006.[57] By then, a catalogue entry has become an occasion to represent 'the work', whereas earlier it seemed an opportunity to experiment with the documentation of the performance — in some instances, an exuberant pen mark on the photograph of the hotel circles the person(s) on the rooftop (fig.7 and 8).[58]

What are we to do with the story that this diversity of visual material appears to tell? Should we reject it, and assume that the performance in 1979 was immediately transformed into its current and final materialisation?[59] We would still need to provide an explanation, or, better, a reading of the variations within the edition of five. These could be attributed to extraneous circumstances — simply witness to the thoughtlessness with which works are presented in the publications that feed the art system.[60] We could conclude that their variance is negligible,

as only the iconography of the work counts. But against this I would propose two arguments: if details are irrelevant for an understanding of *Triangle*, why is the English translation describing the performance, or rather a certain passage of this text, worked over again and again? Iveković keeps refining the wording that describes her activity on the balcony, so that what is ambiguously worded as 'I sip whiskey, read a book and make gestures as if I perform masturbation' — provoking the question whether she is doing or acting — elsewhere is described more precisely: 'I drink whiskey, read a book and pretend to masturbate'.[61] Throughout the years, variations have included 'I sip whiskey, read a book and make gestures as if masturbating', 'as if I am masturbating', 'as if I was masturbating' and 'as if I perform a masturbation' — ambiguity slipping back in.[62] Against a rhetoric of the finished work, these small changes keep the artist involved, as if *Triangle* needed some slight instability in order to stay alive. In another context, on the subject of her frequent collaborations with activist organisations, Iveković tells us:

> But I am also ready to fight for a visual language of my own, the one I consider best suited to give shape to a project, in order to establish communication with the public and create a greater visibility for a given project.[63]

Notice the spirit of this quote, the tenacious attitude concerning her own practice, her desire to 'establish communication'. This would be my second argument: if we take the changes apparent in the diverse visual manifestations of *Triangle* from 1979 until now to mean something, we might be able to propose a speculative narrative on how Iveković works.

But before attempting this, a number of related questions ensue. What is the ontological status of the work? Is *Triangle*'s visual

representation a trope utilised in an effort to make the work count? And to whom is it addressed? Finally, what does the materialisation of the work tell us about the conceptual stance of Iveković's practice? And what is the status of the artist (her role, her conceptual investment in doing the piece)?

The fact that Iveković had her performance documented indicates that she had in mind some subsequent use of the documentation. The variations in the material she publishes — and there is much that was not published at the time — point to its ambivalent representational status. This is not a simple transfer of live action onto paper, nor a straightforward visualisation of a previously formulated, ironclad concept. Iveković worked and reworked the piece by harvesting the documentary images she had at her disposition. Today, *Triangle* resides firmly in the two-dimensional format, yet its foundational premise remains the original performance. Because the performance is absent to us, only relayed second hand, by a narrative and the documentary images, it takes on the character of an enabling fantasy, a story of origin to be told (and controlled) by the artist.[64] There is some indication that photographs might have been taken on different days, but does this matter?[65] I think not. What matters is not whether the photographs were actually taken during the performance, but that they might well have been. It is not their documentary character per se that is decisive here, but the fact that the work claims their documentary character. What David Green and Joanna Lowry write about Robert Barry's *Inert Gas Series* (1969), a piece in which he released several inert gases into the atmosphere and then documented them through several landscape photographs, also suits *Triangle*: 'The intended effect of the photographic statement is to produce our belief in the existence of this invisible phenomenon, rather than simply to witness it being there.'[66]

If the photography of *Triangle* can in this sense be said to be performative — it not only traces an event, but constitutes its actual realisation — the same effect must be attributed to the textual description of the performance: it claims that Iveković performed 'gestures as if masturbating', and that a policeman rang the bell, ordering 'that the persons and objects are to be removed from the balcony'. We have no way of knowing whether this is true. Certainly the visual evidence does not confirm it. Nevertheless, it is true simply because the work claims a truth value, and because the work itself is true, insofar as it exists. Green and Lowry argue that for Barry's action to be effective, certain conditions must be fulfilled: 'The photograph has to be taken by or authenticated by the artist, the date and time have to have been recorded, its passage into the public domain has to be controlled by the artist and it has to be displayed in a particular way.'[67] This sounds like a recipe for *Triangle*.

But here is the problem: Sanja Iveković is not the kind of artist who relishes the position of being the mythical source of meaning. Authentication of the work and control of its passage might be a necessary evil if one is to 'establish communication'. But the fact that it was so difficult at the time to get rid of the artist-subject must have been frustrating to her. Much of the institutional critique developed by the New Art Practice took on self-referential forms, with an emphasis on the establishment of autonomy of space and artistic self.[68] Goran Trbuljak's *Ne želim pokazati ništa novo ni originalno* (*I Don't Want to Show Anything New and Original*, 1971) — displaying a headshot of the artist and, in large script mimicking an advertisement, his name — sums up this approach quite well. Despite the fact that Iveković's early works proposed a critique of the politics of representation, and even though she had declared herself a feminist, she was seen to be expressing 'her own personality ... as essential part of her art'.[69] 'Local critics (male, of course)

understood my work as (only) an auto-referential attitude...'[70] Iveković had to act against the artist-creator myth, not only because it shackled her sociopolitical concerns, making them invisible, but because the particular model of female artist available at the time was less desirable than its male counterpart. On one occasion she is attributed a 'sensibility as femme artiste'.[71]

By displacing the performance of *Triangle*, as well as the performative gesture, from the site of the artist-subject into a material form to be perused by others, Iveković manages, I would argue, to redress the problem of an uncomfortably sealed authorship. Even though, as Green and Lowry maintain, authentication is a necessary requisite for the photographic installation to come into existence as a work, and even though the performance still reverberates, in many ways today's *Triangle* has acquired a manifest presence independent of its auctorial inception. Its matter-of-factness, its no-nonsense attitude and its making do with the bare minimum that is needed for an adequate description of a scene combine oddly with a successful formal solution that goes further than the mere documentary description of the performance. I would therefore conclude that such materialisation of *Triangle* is less the result of an interest in obtaining an art object that can circulate in the art economy than of a materialist stance (albeit not in the most ideological sense of the word). Its materialism is one that is brought into play against myth and fetishisation.

The story Iveković is telling with *Triangle* is most probably a story that only she can tell. And she can only tell it through herself, as she has told numerous other stories — analyses such as *Double Life* or *Dug put do slave i popularnosti: Tragedija Jedne Venere* (*A Long Way to Glory and Popularity: Tragedy of a Venus*, 1975; fig.15). But, and this seems absolutely pertinent to me,

it is not a story *about* herself, even though this story is *also* about herself, just as stories by artists such as Adrian Piper, Lotty Rosenfeld or Šejla Kamerić are *also* about them. *Triangle* is a story about an issue that needs to be made apparent. In order to make it matter, Iveković has to give people the possibility to see. And seeing is more than bearing witness to a performance or its recounting. It implies understanding. In order to establish communication, a visual language must be found, and this is more important than mirroring a performance. The story needs to be distilled, it requires a concise, even polemical form. If a perfomative event can be described as the enactment of a proposition, the published piece contains its result. And in the case of *Triangle*, the artist has inserted between proposition and result no mirror, not even a camera, but the tools of analysis.

4. New Art Practice in Yugoslavia: An Account

She was not alone. A considerable amount of time and effort has been spent in recent years on writing the history of what has been coined 'neo-avant-garde art' in Eastern Europe. The general sentiment amongst those who have taken part in this ongoing endeavour seems to be that, aside from research into local and national contexts, a horizontal mapping of currents and crosscurrents in the geo-political region needs to be further developed.[72] A horizontal perspective makes sense for two reasons. Firstly, artists and art scenes did relate to each other across national boundaries,[73] but much of the material concerning their exchange has previously been neglected. Secondly, as the political climate changed in similar ways in several countries under real socialism in the 1970s, there seems to be enough common ground to compare and contrast.[74] How did artists and art scenes negotiate this period of political pragmatism, in which the previously all-encompassing role of ideology in shaping society was replaced in part by a budding consumerism? Piotr Piotrowski, who has addressed this question, qualifies it:

Because real socialism took a different form in each country, especially concerning cultural politics, individual neo-avant-garde trends such as Conceptual art or Body art had different meanings in different areas of East-Central Europe.[75]

This caveat seems to imply that there existed no discourse inherent to artistic practices that could have influenced both the look and the meaning of what was being produced internationally. Nevertheless, Piotrowski has a point.

Take two photographs from the time that look remarkably similar, both documents of actions in public space. In 1970, Braco Dimitrijević himself is carrying a handheld rally or advertisement sign with the image of an unidentified passer-by through the streets of Munich (fig.26).[76] In 1972, Bálint Szombathy participates anonymously in a 1st of May demonstration in Budapest, carrying the same kind of sign with an image of Lenin (fig.27). Both artists are part of the New Art Practice (Dimitrijević in Zagreb and Szombathy in Novi Sad) and most certainly knew each other. The two works the photographs document, *Casual Passer-by I met at 2.04 PM, Munich 1970* (1970) and *Lenjin u Budimpešti* (*Lenin in Budapest*, 1972), garner some irony from their chosen means: an ambivalent sign, which might be used either for commercial goals or for political propaganda. Whereas normally context helps us distinguish between uses and thus delimits their purpose, here the works trade on the signs' contingency.

Like Szombathy, Dimitrijević comments on the similarity of propaganda to advertising, at least in his earlier series *Casual Passers-by I met at 1.15, 4.23, 6.11 PM, Zagreb, 1970* (1970), depicting pedestrians in the manner usually reserved for Tito and consorts on large billboards placed on a façade

in the centre of Zagreb. And like *Triangle*, the pervasiveness
of images of political leaders in what Bojana Pejić calls the
'socialist iconosphere' — a public sphere both shaped and held
up by (gendered) images — is attacked.[77] However, Iveković's
and Szombathy's are direct quotes (Tito/Lenin), and both
insert themselves personally into a politically charged public
gathering: the difference being that in the 1970s Lenin was a
myth, and despite Tito's by then mythical status in Yugoslavia,
he was also its actual leader, and thus in a concrete way
vulnerable to criticism. In the 1968 student protests in Belgrade,
old images of Tito from the Partisan struggle were used on posters
ironically implying that whereas in the past the leader's words
and deeds had been in unison, he was now failing to keep up
with his promises.[78] Dimitrijević's artistic practice, on the
other hand, aims at a linguistic problem that can only be thought
of as political in the way that Daniel Buren's (fig.23) and Art
& Language's work are.[79] Predecessor of both Dimitrijević's
and Iveković's work, though closer in attitude to the latter,
is the early film about a 1st of May parade in Belgrade directed
by Dušan Makavejev. *Parada* (*Parade*, 1962; fig.24), focuses
the camera's view solely on the preparations for the spectacle
and on a rather disinterested crowd, irreverently neglecting
official representatives and their stagings. The film diverts
the heightened emotion that such events are meant to evoke
onto everyday matter-of-factness and routine. It was promptly
censored.[80]

Even these few examples show that it makes sense, in the case
of Yugoslavia, to carry Piotrowski's observation even further,
from a national onto a local plateau. For aside from individual
differences, the variety of approaches and solutions in Ljubljana,
Belgrade and Zagreb were linked to the different cultural
situations in each place, as Ješa Denegri noted already in 1978.[81]
What this might mean can be shown in a comparison, albeit

a very simplified one, of the art scenes associated with the Studenstki kulturni centar (Students' Centre or SKC) gallery in Belgrade and Galerija studentskog centra (Student Centre gallery or SC) in Zagreb. These galleries actively contributed to the New Art Practice's development, whereas, for instance, art academies — associated with outmoded pedagogy, modernist aestheticism,[82] conformist ideology and the social privilege that goes with the latter — were irrelevant to its formation.[83] It was at the SC in Zagreb that Sanja Iveković first exhibited, even before she had left art school. Moreover, in addition to putting up conventional exhibitions, the centres were generating new formats, enabling a turn to process, to performance and to the transgression of the physical confines of the gallery space, in synchrony with international events. Because there was no art market to speak of and little other institutional support, artists organised themselves in more or less informal groups, creating short-lived exhibitions in places like the foyer of an apartment building in the centre of Zagreb,[84] or meeting in Iveković's apartment for heated discussions on art and politics.[85] Denegri writes:

> In Yugoslavia the associations were not only the result of the artistic affinities of their members but also of the artists' day-to-day contacts based on similar attitudes to life and partly on their isolation from other social or professional groups.[86]

This rather private hustle and bustle spilled over into the activities and events at the Students' Centres galleries, which gave artists the opportunity of working in slightly more formal situations. These venues were important not simply because they gave artists spaces to experiment, but because they enabled them to perceive of an audience as audience, and thus they constituted micro-public spaces.[87] But, as with any public space, they had their drawbacks.

The SKC in Belgrade had been created in the wake of the student protests in 1968. Unlike other European governments at the time, the Yugoslavian rule had initially sought to put a positive spin on the students' movement, which actually started around the mid-1960s, by defining it as an expression of the government's policy of self-management.[88] The students in turn articulated their demands seemingly in conformist terms, invoking the state where students elsewhere were wanting to smash it:

> *Our programme is the programme of the progressive forces of our society — the programme of the (governing) League of Communists of Yugoslavia and our constitution. We want it to be put into practice immediately.*[89]

That last sentence, however, was anything but compliant; in fact, it pointed to the critical gap between the rhetorics and the implementation of official ideology in Yugoslavia. The network of self-management, which was supposed to wither away the state, did not extend to strategic industries or to the financial system, which were governed centrally. As was education. Political and economic power was not distributed according to brotherhood and unity, the tenet of the state (together with non-alignment and self-management). Aside from stark regional disparities, the biggest problem was the widespread corruption of the bureaucracy and its 'red bourgeoisie'.[90] Work migration, mass unemployment, even homelessness were facts, but the government did little to rectify these situations. And even though the lack of women's political representation and their social and economic inequality were endlessly referred to in speeches during party congresses, no action was taken.[91] Except for the discrimination of women, all these problems were addressed by the students in their catalogue of demands. Iveković, talking about the political

attitude of the people she was associated with in the 1970s, has said: 'One can rightfully say that those who were active on the countercultural scene at the time took the socialist project far more seriously than the cynical governing political elite.' [92]

Her comment is in line with the ideas generated by the students' movement that climaxed in the student strikes in 1968. After all, this was her generation — she graduated from art school in 1971. Many factors contributed to the change in policy towards the students' movement at the end of the 1960s. Amongst them were external threats: of a potential Soviet involvement, and of the withdrawal of US aid when the Vietnam War was raised as an issue in the protests. What was probably perceived to be more dangerous were signs of increasing solidarity between workers and students. There had been a considerable surge of strikes all over Yugoslavia, and the establishment feared that the workers would join in with the students' strike in 1968. Moreover, the political situation was fraught with an ongoing internal struggle in the Savez komunista Jugoslavije (SKJ), or League of Communists of Yugoslavia, over diverging economic strategies. The liberals wanted further regional autonomy, a strengthening of the power of individual federations and a degree of democratisation, while the conservatives argued for a unionist centralisation, eventually becoming nationalists and threatening federal cohesion. Repression and attempts to co-opt student leaders into the communist bureaucracy alternated depending on which of the factions within the ruling party had the upper hand. In June 1968, police attacked thousands of students marching towards Belgrade's city centre. The next day, Tito publicly acknowledged the students' demands as rightful. Yet this remained rhetoric. De facto, books and films were censored, and academia purged.

One might imagine that the widespread, often ironical exploitation of the gap between signifier and signified, and between language and image, in the art of the time were not just a result of an interest in Marcel Duchamp or René Magritte, but also an attempt to cope with the impotence people must have felt as they were confronted with the discrepancy between the political rhetoric of those in power and their everyday reality. Take the *Crveni Peristil* (*Red Peristyle*) intervention in public space by an activist artists' group on 11 January 1968 (fig.25) — an intervention that was at the time considered a student's prank.[93] Overnight, the pavement of the Roman central square in Split was painted red, and the highly symbolic red square made real. Isn't this a kind of self-management? Taking matters into one's own hands? Insisting on the red being put into practice? It was, at the very least, an attempt at interpellation: 'You there, red bourgeoisie, come down here and put your money where your mouth is.' [94]

In another example, Mladen Stilinović's *Umjetnik radi* (*Artist at Work*, 1978; fig.28), a series of eight photographs of the artist sleeping in bed, it is easy to imagine that the irony caused by the conflict between word and image was an assertion of artistic autonomy, but it might equally be interpreted as an acerbic comment on the functionalisation of artists within Yugoslavian society.[95] Many of Iveković's early works also thrive on the discrepancies of signification, for instance, when she videotaped only a quarter of the televised image during the national news, (*Gledanje*, or *Looking At*, 1974), or when she recorded the televised advertisements of consumer goods and propaganda from a television screen that had been painted with black stripes to suggest prison bars (*Slatko nasilje*, or *Sweet Violence*, 1974; fig.14). It is already apparent in those early videos that a major source of her social critique derives from alert scrutiny of mainstream media.

Generally seen as a result of the student strikes in Belgrade, the Student Centres founded by the universities were often questioned in terms of their role in the negotiation between artistic autonomy and the government. Were students 'given a cultural venue as a way of channelling their dissatisfaction into a marginal cultural experience'?[96] The fact is that the SKC in Belgrade evolved into a new kind of cultural institution that experimented with anti-hierarchical models; provided a space for unfettered discourse on art and politics; gave a home to new art practices; and evoked a lively international exchange between artists, curators, film-makers, musicians and people from the theatre scene. It was here that the seminal feminist conference 'Comradess Woman. The Women's Question: A New Approach?' was staged in 1978, the first one to be organised autonomously, under heavy criticism from women's organisations within the Communist Party.[97] Nevertheless, the conflict about dependency on and freedom from governance shaped the discourse of the New Art Practice in Belgrade,[98] which leaned towards a more politicised form of institutional critique than its counterpart in Zagreb. This can be seen by comparing Goran Trbuljak's statement 'I do not wish to show anything new and original' (1971), originating in Zagreb, with Goran Đorđević's (unsuccessful) call for an 'International Strike of Artists' in Belgrade (1979).[99] And while Braco Dimitrijević's institutional critique was general enough to be easily transferrable to the West, artists associated with the Belgrade SKC were busy organising, in opposition to the state-run Belgrade Salon, their own October Salon in 1975, which had a particularly local topic: the 'collective rethinking of the potential of the principles of self-management in the field of culture'.[100] This kind of approach would begin to make sense to the Western art system only in the neoliberal 1990s. While some contemporary cultural critics have projected today's critique of neoliberalism back onto the Yugoslavian situation in the beginning of the

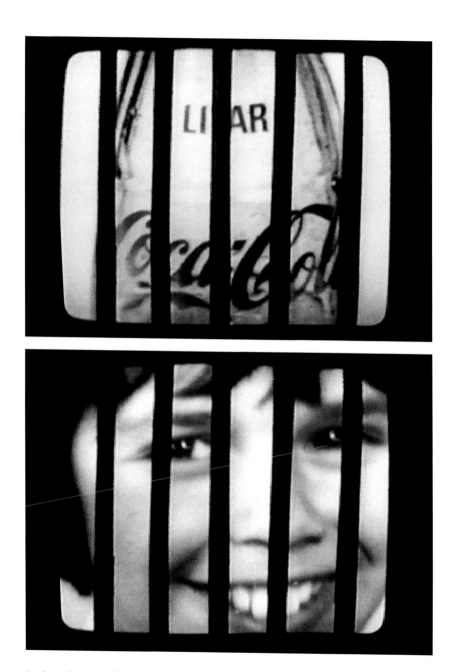

14. Sanja Iveković, *Slatko nasilje* (*Sweet Violence*), 1974,
video, black and white, sound, 12min. Photograph: Marko Ercegović

Zvali su je i tigricom

Izabrala je Di Mađa

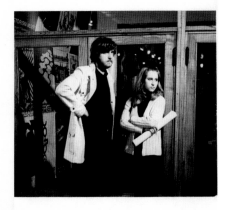

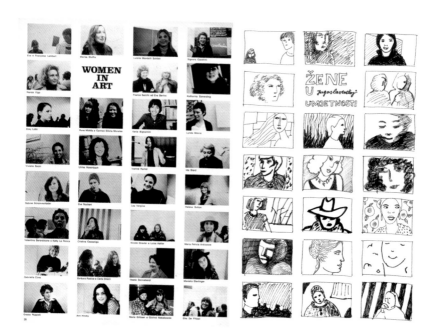

15. Sanja Iveković,
Dug put do slave i popularnosti: Tragedija
Jedne Venere (A Long Way to Glory and
Popularity: Tragedy of a Venus), 1975,
series of 25 photomontages, 41 × 58cm each,
details

16. Sanja Iveković,
Women in Art — žene u jugoslavenskoj
umjetnosti (Women in Art —
Women in Yugoslavian Art), 1975,
photomontage and ink on paper,
21 × 30cm

17. Sanja Iveković, *Dvostruki život (Double Life)*, 1975,
series of 64 photomontages, 41 × 58cm each, details
Images: © Generali Foundation, Vienna

Juli 1975.Vrijko.ла Чаптем ла vrijeme smimanja film "Lisbon".

Август 1975.Na izletu Zagreb—пешке u okopotmoj.i posjeti Граждчaj жестri.

Sanja Iveković u atelieru pri radu na svom novom djelu.

18. Sanja Iveković,
*Likovni radnik u svom radnom prostoru
pri radu (Artist Working on Her New
Piece in Her Workplace)*, 1977,
photograph mounted on paper with text

The typewritten text translates as:
'Sanja Iveković in her studio working
on her new work.' The handwritten text
translates as: 'Best regards to the organisers
of the "Inovacije" exhibition.'

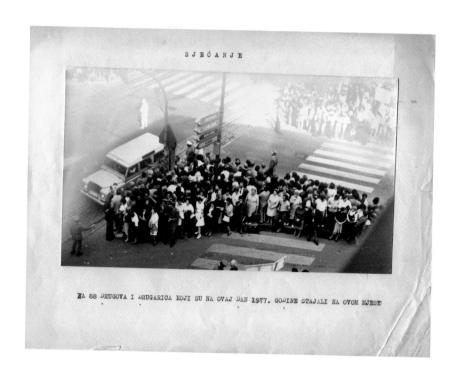

SJEĆANJE

ZA 88 DRUGOVA I DRUGARICA KOJI SU NA OVAJ DAN 1977. GODINE STAJALI NA OVOM MJESTU

19. Sanja Iveković,
Spomenik (Monument), 1979,
black-and-white photographic print, spray
paint and typewritten text mounted on
paper, 30 × 21cm

The text translates as:
'Remembrance
In memory of 88 comrades and comradesses
who stood on this particular spot in 1977.'

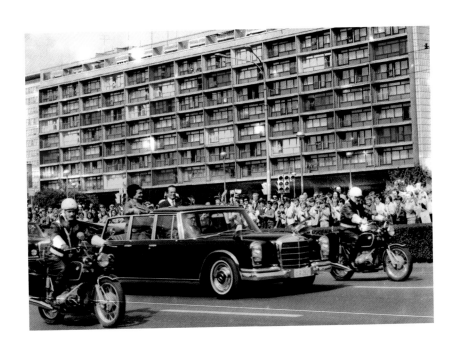

20. Sanja Iveković,
Novi Zagreb (Ljudi iza prozora) (*New Zagreb
(People Behind Windows)*), 1979,
hand-painted photo-collage,
87 × 117cm

1970s, I doubt that this is viable from either an economic or a cultural perspective.[101] Rather, the ambivalences that arose from adopting (even critically) a concept put forward by the government, a concept which was at that time generally read as more than just an economic term, 'meaning worker-oriented, free, self-actualising and progressive all at the same time',[102] are simply ambivalences of governmentality. Their being located in 'socialism made in Yugoslavia' provided artists with a particularly keen awareness of what Michel Foucault described as interplay between self-direction and direction by others, or a set of actions that elicit other actions.[103]

5. Democratisation of Art in Zagreb: A Problem

Artists coming of age in Zagreb in the 1970s responded to a slightly different set of actions and thus the questions they posed about subjectivity and society diverged from those in other parts of Yugoslavia such us Belgrade, Split, Novi Sad or Subotica, though not by much. Their solutions, in fact, were similar to those found internationally at the time. Although the West kept itself mostly ignorant of what was happening in Yugoslavia, proponents of the New Art Practice were reading Lucy Lippard, referring to exhibitions such as 'Op Losse Schroeven' and 'When Attitudes Become Form' (both 1969), and meeting with the likes of Daniel Buren, Victor Burgin or Lawrence Wiener.[104] Works by Christian Boltanski, Sol LeWitt, Jannis Kounellis, Jan Dibbets and numerous others were being exhibited in Yugoslavia early on.[105] But familiarity with art production elsewhere is not the only reason why it makes no sense to differentiate too strictly between Zagreb, Belgrade and Ljubljana. The number of artists working in the field was modest, probably around fifty, and people were acquainted with each other and often worked across localities — after all, the venues for showing the new art were scant.

Nevertheless, from what I can gather, the discourse produced in the vicinity of the Students' Centre Gallery in Zagreb and the Gallery of Contemporary Art[106] differs from the one in Belgrade in that it remained focused on art 'as art', eschewing politics. If there were a political term to be culled from it at all, it would be the 'democratisation of art'. I don't mean to suggest that this implies the absence of politics; but if we are to gauge its meaning, and ultimately relate it to the development of Sanja Iveković's practice into what is today a highly politicised stance, the ineluctable politicality of the notion of 'democratisation' must at least be called into question. For democratic strategies employed by artists diverge, just as there exist different forms of democracy itself.

Consider, for a moment, one of the doctrines of democratic agency, the concept of participation. By building the Workers' Clubs in the 1920s, Konstantin Melnikov, Alexander Rodchenko and others saw themselves as forging a new society. The Workers' Clubs were more than meeting places for a public, which they defined quite statically in relation to the means of production; they were 'sites of contestation over the definition of a culture with respect to daily life'.[107] Contrast this to the 1980s, a time in which the notion of a stable public is criticised and replaced with that of heterogeneous audiences.[108] In retrospect, it is possible to identify a general tendency by artists following in the wake of Constructivism, in particular since the 1960s, to take on the role of micro-political facilitators, coupled with a readiness to relinquish claims to power and to move the onus of participation to those being addressed or engaged. Within a democracy framed by capitalist consumerism, this process, at least in its mainstream manifestations, has eventually lead us away from the ideal of a politicised audience to relational aesthetics, or the neoliberal art of the 1990s. The meaning of participation in art has through this shift come to correspond

with participation in other areas of society, such as education or the healthcare system, which have been refigured according to the new spirit of capitalism.[109]

What then did the proposal to 'democratise art' mean in Zagreb in the 1970s? 'Democratisation' was a charged word at the time, with a particular local history. Eastern European Conceptual art tends to be assigned various degrees of dissidence in relation to the conditions under repressive communist regimes. Some have, not incorrectly, gone as far as to imbue small gestures in the public space with deep political meaning — the elaboration of codes or messages that could and would be read by the public as subversive.[110] Yet, such emphasis on dissidence overshadows the fact that political power in Yugoslavia was less homogeneous than could be assumed, despite its one-party system and all-pervasive Titoism. In fact, the decade between 1963 and 1973 was characterised by tectonic shifts in economic policy, by various experiments with political reform and by an increasingly heated debate about the benefits or drawbacks of the centralised union of republics within the Communist Party, the regional administration and the central government.[111] To summarise, what started out as an economic liberalisation,[112] turned into a political battle about system change and culminated in an inter-ethnic conflict that had its symbolic resolution in the quelling of the misleadingly named 'Croatian Spring'[113] in the early 1970s by Tito. During this period, the call for democratisation was voiced not only by the 'people in the street', but wielded by a number of political players with various interests in mind. But let's backtrack slightly, gleaning a digest of the complex unfolding of events from a history of Yugoslavia written by political scientist Sabrina P. Ramet.[114]

In the beginning of the 1960s it became apparent that central economic planning was not only unpopular[115] and inefficient,[116]

it was also not helping to solve the severe economic crisis
that Yugoslavia was going through. The government initiated
a number of reforms, of which 'self-management' was only
one catch phrase. It opened its economy to the world market,
relaxed wage control and reorganised its financial markets
— although it kept foreign trade and the banks close to
the Belgrade chest.[117] Decentralisation did not stop with
economic policy, but also included the shift of power to regional
governance by the different republics, as well as the creation
of a network of inter-republican committees, which de facto
started to supersede large parts of the central government's
administration. It also eroded the control of the Communist
Party, as delegates to national bodies were allowed to vote
according to regional interests instead of following the party
line. This experiment in democratic liberalisation was not
carried through without controversy; in fact, the fault lines
between conservative unionists and liberals, between rich
and poor republics and finally between ethnicities ran
through all governing bodies and all regional Communist
Parties. People were toppled and thrown into prison on both
sides during these years. But by 1967 the liberals had the
upper hand.

The defence of regional interests came to be synonymous with
a rhetoric of democratisation, yet even the most vehement
supporters of liberalisation never challenged centralism per
se.[118] Did Belgrade have the interest of all republics in mind?
It did, for example, redistribute wealth and foreign capital
accrued by Slovenia and Croatia to underdeveloped republics,
such as Macedonia.[119] Serbian hegemony, however, contributed
to the flare of nationalisms towards the end of the 1960s.
And although Ramet makes an interesting point, arguing that
some Serbian chauvinism could instead have been read simply
as a product of a modernist policy, it wasn't.[120] While inter-

ethnic conflict and inter-republic frictions predate the period of economic reform and systemic change (and sadly post-date it in the wars of the 1990s),[121] the debate between liberals and conservatives about political legitimacy only took on nationalist garb after a time. Croatian politicians couched what was essentially an argument about enfranchisement and distributive justice in ethnic terms. Unfortunately for the Croatian government, their political posturing was soon underscored by the development of a mass movement, which virtually took over the discourse. As one participant has said, 'The whole political life, which had been closed to the public, now opened up and people started to speak their minds, both about the way things were then and how things had been in the past.'[122]

A desire for true democratisation was one reason for the Croatian Spring, which was also fuelled by the perception that Croatia was being economically exploited and culturally colonised. Yet left-wing and independent participants soon lost all control to the truly demagogical cultural association Matica hrvatska, whose ideology was nationalist, racist and retrograde.[123] Croatian politicians formed an alliance with Matica hrvatska, probably because they wanted the populist backing, thinking erroneously that this show of might would finally sway Tito towards liberalism. This alliance, which culminated in a strike of 30,000 students in November 1971, was a strategic error on the part of Croatian politicians: by failing to suppress Matica hrvatska, by pushing for a separate currency and even Croatian secession, by reclaiming right-wing military governor Josip Jelačić as a lost hero, by instigating anti-Serbian laws and by laying claim to extra-Croatian territory, the liberals forced Tito's hand. With the consent of the US government, Tito decapitated the leadership of the Croatian government, expelled around 10,000 Party members, stripped people working in culture and education of their posts (although not artists)

and sent in tanks to intimidate the last 500 students who rioted in Zagreb for four days in December 1971. After this, some of the nationalist demands of the Croatian Spring movement were granted, but the decade-long reform experiment led by liberal politicians and the left-leaning civil society was dead. Instead of political liberalisation, the country got 'decentralisation without democracy'.[124]

1971 is also the year that Sanja Iveković emerged as an artist. Imagine the atmosphere in the street. And then consider her statement: 'the paradox was that we as artists had serious intentions of "democratising art", but the artistic language that we were using was so radically new that our audience was really limited'.[125]

Why would the artists continue to employ a language that was understood by so few? And the aestheticised modernism that was propagated by the Yugoslavian state in the 1960s and 70s, had it been understood any better? I doubt it. The alienation between avant-garde art and the public, which artists always seem to reckon with but equally count on overcoming, was not caused by the New Art Practice, no matter how esoteric their language was. No, this detachment must have been immutably sealed in the years before: because the state sanctioned not only abstraction but also, and more importantly, visual art's autonomy,[126] it impeded both any real dissociation between art and hegemony and any real encounter between art and audience, which requires, as all communication does, the acknowledgement of possible failure from the outset.

Absurdly, it was by insisting on being close to the public and engaging in making socialism work that artists were able to carve out a space for themselves, one not preordained to them by the state.[127] The democratisation of art was then first and

foremost a speech act, and as such functioned as an instrument for self-definition. Where it turned towards concrete political issues, it risked censorship.[128] Where it remained abstract, it provided a setting for a serious examination of the institutional, psychological and phenomenological conditions of making art. But in its abstraction, it also procured an image of the other, that nebulous conglomerate of power, stasis and corruption as a homogeneous entity ('the system'), contrary to actual experience and factual knowledge of the complex state of things.[129] And despite all the activity in the public sphere — 'interventions in urban space', as it was called then — and all the solicitation of the gallery audience that the Zagreb scene came to be known for,[130] it entailed a dissociation from the public: addressing an audience might have been meant as a political act, but there seems not to have been a concept of the audience itself (or, as a matter of fact, of the public) as a political entity, with which one might forge concrete bonds in some kind of political activism. No wonder. Where could that kind of political thinking have come from, when civil society proved to succumb so easily to both Titoist and nationalist populism? Surely, the images of people assembled like sheep on a traffic island awaiting the parade, of avid consumers taking in Pepsi or Coca-Cola advertisements on state television and of Ivan Kožarić's public sculpture *Prizemljeno Sunce* (*Grounded Sun*, 1971; fig.21) burned to the ground by a mob took their toll.[131]

6. Taking Personal Responsibility: A Solution

The need to start anew is most definitely what separated young artists like Sanja Iveković from an older generation. They had to refigure the role of art not as a rite of passage, but for another reason: the sociopolitical foundations upon which to place the artist's self had been acutely shaken. Although both the 'belief in the participation of artists in modifying everyday life'[132]

and the resistance against the institutional functionalisation of art had been formulated by predecessors to the New Art Practice in Zagreb by groups such as EXAT 51 or Gorgona, new categories were required because the context had changed.[133] Iveković shares with other artists of her generation the conviction that artistic practice can be a means to arrive at those categories. Taking on the self as a figure of the work — or, alternately, as a means of bringing it about, performing it — was seen by them as a method to understand and define the self; to understand and define the artist's role within society; and, finally, maybe even to understand and define society. Certainly, this kind of interrogation can also be found in work made in the 1960s, such as by Tomislav Gotovac's prescient *Pokazivanje časopisa Elle* (*Showing Elle Magazine*, 1962; fig.22), for which, in the middle of a wintry forest, he holds in front of his naked chest a magazine opened to display advertising images of sexualised women. Many questions can be raised in relation to this work, about gender, or about the discrepancy between consumer images and everyday reality. But, primarily, it is an image of an artist behaving in a perplexing way, and thereby challenging the limits of the aesthetic subject and method.

It is Iveković who first focuses on the link between the self and society in earnest. With *Double Life*, she introduced what today is called intersectionality, the relationship among multiple dimensions and modalities of social relationships and subject formations, to the visual art of Zagreb.[134] As Branislava Anđjelković has written,

> Iveković, by identifying her own situations and postures from the past with specific advertisement images, comes not just to her own double life but to the whole complexity of ideological and gender issues in the socialist Yugoslavia

[...] Unlike her male peers, she approaches [...] ideological frameworks with serious caution. She is aware that there is no such thing as an objective distance, that there is no way that non-involvement or some puritan exclusivism can lead to meaningful criticism.[135]

In other words, there is more to this operation than involving oneself with issues of social inequality, because the self is always already in the picture.

This is where Iveković differs from Gotovac: the self is shown in her work as part of what Michel Foucault called a 'dispositif', a term that refers to the relationship between the self and other coordinates or instruments, which together make up our historically specific take on reality and allow for our contingent agency.[136] How come the artist knows this? How come she understands that a *dispositif* is not based on a hierarchy that privileges (or de-privileges) the subject? I would venture that Iveković does not 'know' this in a discursive sense, not in the way that the psychoanalytically inclined Slovenian theorists started to know it at the time and not in the sense that the philosophy students in Belgrade searched for in the work of Louis Althusser and Gilles Deleuze. Of course, Iveković read works such as John Berger's *Ways of Seeing* (1972). (His analysis of the hidden ideology in visual images from Renaissance art to contemporary advertisement and his deliberations on male spectatorship and female objectification were decisive in her feminist turn.)[137] However, the artist's knowledge of the *dispositif* derives at least in part from practice. The experiment of recording with a video camera the lower right quadrant of the national TV news broadcast in *Looking At* leads to the insight that a change of frame or format can change one's perspective on what is purported to be a representation of reality. In *Sweet Violence* this formal principle is extended to TV Zagrebs's 'economic propaganda

programme', provoking an awareness of the interplay between the televised images and our own ambivalent position as viewing subjects.[138] On which side of the prison bars glued on the television screen are we — entrapped in the socialist iconosphere (which now includes consumerism) or identified with the artist's critical redesign? Here, artist and viewing subjects are implicated by proxy, but a year later, in *Double Life*, Iveković paired snapshot portraits of herself and advertisements on a picture plane without prejudice. And thus they come to affect and effect each other. This method is then re-examined and expanded in the works that follow.

A few years onwards, formalist strategies are put to very deliberate use: in *Triangle* radically different social formations are made contiguous by being treated serially, cropped to the same size and put into a grid. This is not the grid of functionalist architecture, not the one that makes elements self-same with each other. Her method can be compared to the montage of Sergei Eisenstein's films, though in Eisenstein the collision of discontinuous elements is forced into a synthesis, a whole. The montage of Jean-Luc Godard would probably be a more fitting comparison, because the film-maker, whom Iveković admired at the time, propagated a form of editing that emphasised the connection between things while retaining their quintessential difference. This is important, because it is the only way to allow the structural qualities of the *dispositif* to appear — its violence, for instance. In a lecture from 1978, Godard explains:

> The amateur filmer only films one shot. He films his children or how his wife comes out of the water at the beach. And then Christmas or their birthday. Just as the advertisements for cameras suggest: film your child as it blows out the candles on the cake. But there are never two images. Kodak tells you: film this image. It does not say: and then film the

*image where you hit your child in the face. Because from that
moment onwards, one would have to show interest in one's
family life.*[139]

Iveković, like Godard, adds one plus one in order to make the
dispositif visible; later on, she folds the different elements back
into one image, as, for example, in the ongoing series *Ženska kuća
(Sunčane naočale)* (*Women's House (Sunglasses)*), which she began
in 2002.

The principle of radical contiguity, which is used by the artist
against these hierarchies of knowledge and aesthetics that hide
what a society does not want to perceive, is presented to us in
the form of a two-dimensional picture plane. But it equally
holds for the correlation of artist and work. One requires and
entails the other. There is, to paraphrase Kaja Silverman, not
just an author 'inside' the text, but a text inside the author.[140]
In discussing the New Art Practice and the political climate
in Yugoslavia, I presented some of the key aspects of this text
inside the author, in other words what has influenced her
particular formation as an artist. Subsequently, I argued
that the text also comes out of the work itself. Does the text
of feminism also emerge here? This question arises because the
singular appearance of Iveković's feminist art remains a bit
of a mystery. Where else might it have come from than the work?
It certainly was not generated in the discourse of the New Art
Practice, which might have been an obvious setting, had it not
been steeped in (unacknowledged) patriarchy. Other prolific
female artists from the same time and region, like Marina
Abramović, even dismissed feminism. Likewise, it is hard
to imagine that looking at feminist work from elsewhere[141]
or reading John Berger would, on its own, have originated
a politics. I would like to propose as a hypothesis another,
previously unmentioned, trigger in the coalescence of feminism

and art in Iveković's practice, one that points back to the problem of the self in Yugoslavian discourse.

Sanja Iveković once mentioned to me that she was friends with Rajko Grlić, the son of Danko Grlić, one of the philosophers of the Praxis Group, and that they used to sit around the kitchen table, discussing philosophy and politics.[142] The Praxis school of thought must have been attractive to Iveković as a young woman for several reasons, not least because its members had taken an anti-nationalist stand during the Croatian Spring.[143] Critical of capitalist and communist hegemony, they were known for their outspoken opposition to the red bourgeoisie. Against the dogma of Marxism-Leninism, they sought to extrapolate the concept of alienation from early, humanist Marx onto the system of self-management and onto the real (dire) conditions of life in Yugoslavia, arguing for a creative revision of encrusted institutions and stagnant political thought: 'practice is thus opposed to everything established, dogmatic, rigid, static, once-and-for-all determined, fixed, standard; to everything that has become dug into the past and remained hypostatised'.[144] As they maintain, a *'real* revision' of Marxism would also require 'taking personal responsibility. And the fact that an individual (even society as a whole) might have to rely on himself, gives rise to apprehension in the face of the unknown.'[145]

Considered in relation to work *and* everyday life, the category of the individual became a focal point of their philosophy. They saw the individual as a subject of agency, but he or she was not thought to be autonomous in the bourgeois sense. In fact, the individual's task was to help resolve the structural problems existing in Yugoslavian socialism. One need not have sat at Grlić's kitchen table to get a whiff of this change in paradigm from a perspective of class struggle for 'solidary individuation', for the discourse was carried by intellectuals into theatre and literature.[146]

'Taking personal responsibility.' This can only be done if one has an idea of one's own self. At this point, the concerns of the New Art Practice and of leftist intellectuals converged. The self that Sanja Iveković started to formulate in performances, videos and graphic work in the 1970s was never just personal.[147] Even her body-oriented performances either involved the idea of a socialised body or used the body as a medium of social interaction. The goal of enacting social change was always close by. And later on it developed into fully-fledged activist engagement.[148] Yet on Iveković's path towards taking responsibility for more than herself, the hurdle of sexism had to be overcome. Imagine, for example, that in 1973 she came across John Baldessari's *Imagine This Woman Ugly and Not Beautiful* (1973), which was on display in the Conceptual art section of the 'tendencije 5' ('Tendencies 5') exhibition staged at the Gallery of Modern Art in Zagreb.[149] The work pastes its title-sentence over a number of pornographic images of women — who are, by the way, reclining in similar poses to that of Iveković in *Triangle* — in a gesture that might seem critical at first sight. But it does little to challenge the objectifying gaze that the photographs invoke, and an exclusively male perspective is retained.[150] That a deconstruction of an objectifying gaze was attempted but ultimately failed must have been as frustrating then as it is today. After all, via Baldessari's intervention, the offending images had now been introduced into the art world, to lie in wait for the unsuspecting viewer. For a woman living under patriarchy it is inevitable that the visual investigation of the self sooner or later will bring her in contact, if not always into conflict, with sexism. Therefore I conclude that in order to take personal responsibility for political change in Yugoslavian society, Sanja Iveković would have had no choice but to take personal responsibility for a feminist take on the image of woman.[151]

7. An Artist's Work is Never Done: A Poetics

'After a period of time the policeman rings my doorbell and orders that "the persons and objects are to be removed from the balcony".' Thus ends the performance of *Triangle*. The triangle of communication connecting Sanja Iveković, the security officer on the rooftop and the policeman on Savska Street has been completed. Has anyone ever wondered which objects were to be removed from the balcony, and why? The chairs? The whiskey? I doubt that the bottle could have been seen from afar, even with binoculars. The artist herself never offered an interpretation of this strange phrase, and it never occurred to me to ask. I simply assumed that the 'organs of order', which is what Bojana Pejić calls the two men,[152] meant to cover up the embarrassment caused by Iveković's action, and maybe they thought that by listing persons and objects non-specifically their request would somehow seem more objective. And I assumed that Iveković kept the wording intact, because its incongruously officious language precisely exposes the awkwardness that she had managed to instil in these men. But another explanation for the request might be that more was happening on the balcony than we can see on the photograph or read about in the description of the performance. The policeman's statement refers to plural persons, maybe in reference to the photographer who was handling a camera and even, perhaps, using a tripod. This would certainly make any security officer nervous.

Then again, how much was the man really able to see? Maybe he did not recognise the gesture of masturbation for what it was, or, rather, what it was meant to insinuate. Maybe what made him nervous was that he could not identify what was taking place on the balcony. From a panoptical perspective something unidentifiable is suspicious per se. Then again, maybe he could not identify what Iveković was doing because he was

expecting, and probably also observing on other balconies, passive spectatorship. Instead, he himself is made to stand in for the missing audience or public of the New Art Practice, an absurd shift. It is ridiculous in the sense of a joke — two people, representing a mighty whole, cannot make a crowd, even if they were able to engage with the performance in an adequate manner. Yet, in the context of the state's disinterest in providing the kind of institutions that would be able to generate the audience needed by the artists — that is, an emancipated audience — Iveković's performance is playing at cracking a nut with a sledgehammer. The discrepancy between what is there (two observers) and what is lacking (an emancipated audience) is made to appear through irony, but once it is visible it also becomes an accusation. This mixture of wit and seriousness in political claim, of reflexivity and playfulness, characterises Ivekovic's work overall. As if the most ostentatious demands, deriving brashness from utopia, not from outlandishness, needed to be made with a casual flair. And so it is rather incidentally that *Triangle*, by proxy of the observing security officer, enters into a competition of spectacles. Whereas in everyday situations artists' strange stagings — such as Tomislav Gotovać running naked through the streets of Belgrade in 1971 — might be explained away as an error of judgement (the mistaking of people for a public), there is no mistaking *Triangle*'s question: Would you rather watch the spectacle of the old leader for the millionth time or a young woman masturbating? While direct engagement with the actual Zagreb citizens might have proven slightly unsavoury, to claim a mass audience for one's purpose, even rhetorically, is a powerful gesture. To do it by riding piggyback on the mass media's exploitation of the sexualised female body, is witty feminism.

Be that as it may, we do not know the motivation of the men who let themselves be drawn into Iveković's performance;

we can only interpret their behaviour. In 1989, Bojana Pejić
put forward a compelling interpretation:

> *The security men were positioned along the president's route*
> *in order to ensure that nothing would (physically) endanger*
> *his person, when instead they ensured visual order. It was*
> *their judgement that the visual order demanded by the*
> *situation had been disrupted, since the body on the balcony*
> *did not appear disciplined.*[153]

Pejić claims that Yugoslavian public space is de facto 'menspace':
it lacks real women's political representation and gives us
female allegories of socialism in its stead. This gendered
public space Pejić relates to the dialectics of public and private
spheres in European modernity.[154] Moreover, she adds that
it is characterised by a gendered distribution of 'sight': men
look and women are to be looked at. Implicit in her argument
is the proposition that vision and visual representation are
not only effects of a *dispositif*, but actively implicated in its
gendered logic; hence she speaks of a visual order. Also implicit
in her discourse is the idea that this visual order, though
somehow supporting and performing patriarchy, sustains
its power by remaining hidden. Thus, for Pejić the feminist
quality of *Triangle* lies in the fact that the artist succeeds in
provoking an 'enunciation' of the visual order, by forcing it
into verbal representation and by compelling it to transgress
into the private realm: '...we are dealing with an obvious
implementation of power that can, when necessary, declare
that a private space (the balcony) is a public one'.[155]

Pejić's texts on Yugoslavian visual culture and its art production
during communist and post-communist times are amongst
the most knowledgeable and astute, and their emphasis on
the structural quality of patriarchy continues to be as necessary

21. Ivan Kožarić,
Prizemljeno Sunce (*Grounded Sun*), 1971,
gold-painted fiberglass, 200 × 200cm,
installed in front of the National Theatre
in Zagreb
Courtesy Museum of Contemporary Art,
Zagreb

22. Tomislav Gotovac,
Pokazivanje časopisa Elle
(*Showing Elle Magazine*), 1962,
series of 6 black-and-white photographs,
24 × 30cm each,
detail
Courtesy Kontakt. The Art Collection of
Erste Group and ERSTE Foundation, Vienna

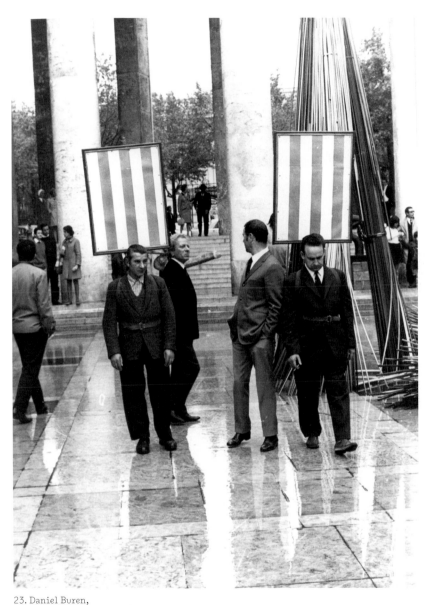

23. Daniel Buren,
Photo-souvenir of *Hommes/Sandwichs*,
work in situ, Paris, April 1968,
detail
© D.B.-ADAGP, Paris
Courtesy the artist and Lisson Gallery,
London

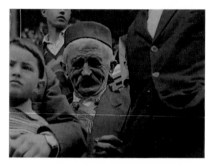
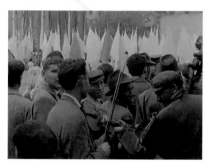
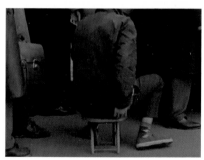

24. Dušan Makavejev,
Parada (Parade), 1962,
16mm film, black and white, sound, 11min,
stills
Courtesy the artist

25. Toma Čaleta, Nenad Đapić,
Dena Dokić,Pave Dulčić, Radovan Kogelj
and Slaven Sumić
Crveni Peristil (Red Peristyle), 1968,
photograph documenting the intervention
on the floor of Diocletian's Palace, Split
Courtesy Marinko Sudac Collection, Varaždin
Photograph: Zvonimir Buljević

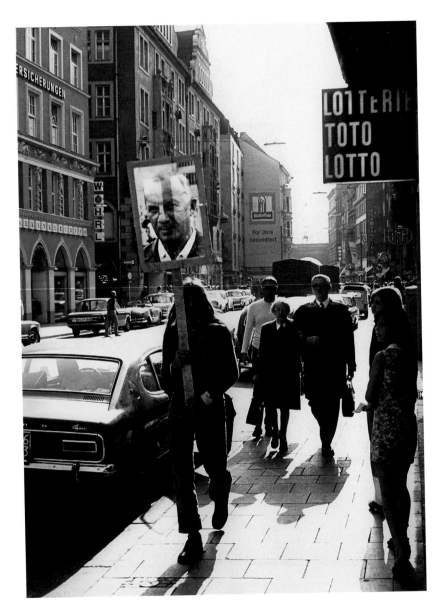

26. Braco Dimitrijević,
Casual Passer-by I met at 2.04 PM,
Munich 1970, 1970,
black-and-white photograph, 42 × 80cm
Collection Gerhard Richter, Cologne
Courtesy the artist

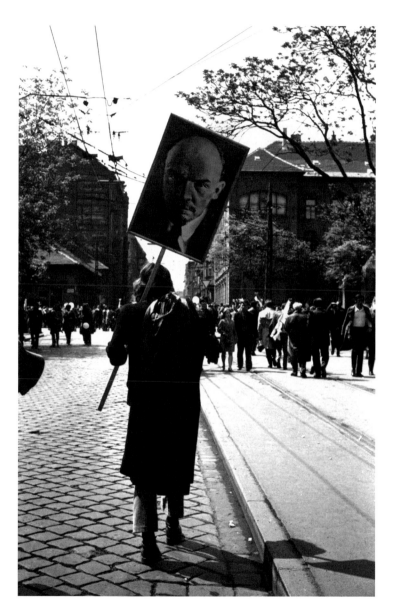

27. Bálint Szombathy,
Lenjin u Budimpešti (*Lenin in Budapest*), 1972,
black-and-white photograph
(from a series of 13) documenting
the street action
Courtesy the artist

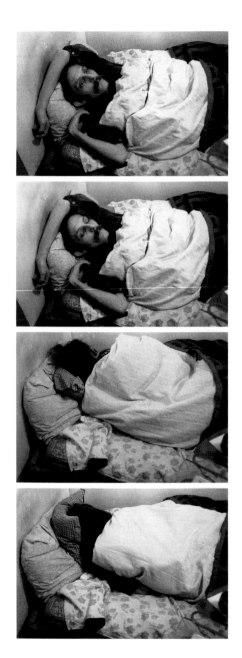

28. Mladen Stilinović, *Umjetnik radi (Artist at Work)*, 1978, series of 8 photographs, 23.8 × 30.3cm each, detail. Collection Van Abbemuseum, Eindhoven. Courtesy the artist

as the tendency to neglect power relations is widespread. Her insight into *Triangle* remains the foundation upon which our gaze can be shifted towards other possible interpretations and meanings. For, from an art-historical perspective, to base the core of one's argument on those aspects of an artwork that are the least factual seems a rather weak strategy. We cannot assume that there is a rationale behind the security officer's and the policeman's actions. We cannot even assume the totality of a visual order, or, for that matter, the coherence of public space.[156] In fact, descriptions that allow for porosity, negotiation and struggle seem historically more adequate. And studies confirm that actual gender practices never completely aligned with the public/private divide. For example, Susan Gal and Gail Kligman show, though not in direct reference to Yugoslavia, that the communist states' intrusion into the private sphere partly freed women from dependency on men, while forcing them into an uneasy alliance with hegemonic power. Some reproductive labour was socialised, like childcare or cooking and washing. Divorce and abortion were made easier. Because they were earning a wage, women were no longer restricted to the private sphere or linked exclusively to its discourse, and their access to the state no longer mediated though their male relations. This gave them some independence from men, though one can argue that the state replaced men as patriarch.[157]

My guess is that there is a deeper problem at work in Pejić's interpretation of Iveković's performance — that the priority given to the police officer's reaction stems from a distrust of the political capacity of the aesthetic properties of art. Proof of *Triangle*'s feminist politics is not searched for in the many features of the work (either performance or documentation), but in the artist's capacity to involve herself directly with a given social context. The reaction that *Triangle* provokes is actually rather banal. As I have tried to show above, it is when

we ask why it provokes such a reaction that we get interesting answers. Should it really be counted as success that the artist has transgressed splendid isolation? After all, it results in an interpellation of the artist as citizen-subject that is almost eerily similar to Althusser's description of the incorporation of individuals into the power structure. There would have probably been no escape from this operation, for power relations cannot be changed by individual subjects or practices. Which, I would assume, is the reason why Iveković later on makes it a habit to cooperate with activist groups. Where the art itself is political, it is grounded in analysis and proposition, or, to use the tattered old avant-garde terms, critique and utopia.

Equal attention is paid by Sanja Iveković to the potentialities and limits of representation and action, to grammar and form. Rather than trading the aesthetic for the political, she performs small concrete and abstract displacements necessary to make other meanings possible. Invited to an exhibition on 'the present art system's (non-)representation of artist's work',[158] two years prior to making *Triangle*, Iveković submitted a photograph of herself, accompanied by a text that reads: 'Sanja Ivekovic in her studio while working on a new work' (fig.18).[159]

The art referred to is hidden in the photograph behind a type-writer. This is quite tongue-in-cheek, as the aesthetic object is produced by the visual denial of the aesthetic object. In excess of this pun, however, appears the figure of the artist herself. Her professional identity is closely tied to the object (not) to be seen, yet she also insists on her identity as a worker. She thereby displaces the curator's question about the (non-)representation of artist's work from the art system onto the socialist system. When they found themselves unable to cover the basic needs and wants of their populace, Soviet states came to count on (officially illegal) production in the private sphere as a means of closing the

gap. Thus the border between paid labour and unpaid reproductive work was blurred.[160] I assume that notwithstanding better living conditions, this was not so different in Yugoslavia. In *Likovni radnik u svom radnom prostoru pri radu* (*Artist Working on Her New Piece in Her Workplace*, 1977; fig.18) and other pieces produced in the 1970s, Sanja Iveković pinpoints the crossing of the two vectors most interesting to her at the time: the role of women and the role of artists in socialist Yugoslavia. For the artists' work and the unpaid reproductive labour done by women in the private sphere share common denominators: invisibility and functionalisation. Though the terms of functionalisation are different for women and artists — and, needless to say, the issue of exploitation of reproductive labour, essential to the survival of any society, is a much graver one — when it comes to Sanja Iveković, in the process of establishing an artist's subjectivity, the similarities matter. Depicting herself in liminal spaces, such as the balcony or the artist's studio (which is in her photograph connoted as private by the intimate lighting and the solitary absorption), she describes the relation of the individual towards the state as a series of ambivalences that colour all aspects of human existence, from work to pleasure.

Let us, in returning to *Triangle* one last time, focus on what Sanja Iveković does. Drinking, smoking, reading, masturbating, performing. An artist making a work; an artist working; an artist engaging in an activity that is highly valued by the socialist state. An artist making a work; an artist working at not working; an artist engaging in an activity that in Marxist utopia is positioned against 'the destructive desire for work'.[161] The product of this work/non-work cannot be fed into the economic cycle without difficulty. Because, in a way, there is no product, just a means of production (the artist's self) and an effect (a new art practice). But this is not without ambivalence. We have seen that, in order to become visible, the performance

needed to be turned into an object, thereby becoming separated from the artist's practice. And while in the 1970s the shift from work towards practice was politically contextualised in the larger movement of self-determination, and thus Iveković was able to set her self against the hypostasis of patriarchal power, Josip Brodz Tito, the politics have changed. Nowadays, the practice of self is inseparable from the governmental control that the individual is asked to — and often agrees to — exert upon him or herself.

Drinking, smoking, reading, masturbating, performing. All contribute to the precarious formation under way. Tito is still alive and the artist's self is yet a figure that can be wielded in the struggle for a better life. Sanja Iveković is focused, despite the ruckus on the street below. Down there (and over on the rooftop), the state is performing, legitimising itself. Up here, Iveković is performing its de-legitimation. She must know that the state would need her to sublimate her political energy, her claims, her ideals. But she refuses the dissidence that would only feed into its phallic regime. In her liminal privacy she enjoys power without gratification.

1
'Feminism, Activism and Historicisation: Sanja Iveković talks to Antonia Majača',
n.paradoxa, vol.23, January 2009, p.6.

2
Original in Croatian.

3
'The creation of the Studenstki kulturni centar (Students' Cultural Centre (SKC))
in Belgrade was the result of student protests in 1968. Students were given a
cultural venue as a way of channelling their dissatisfaction into marginal cultural
experience.' Ana Janevski, 'As Soon as I Open My Eyes I See a Film: Experiment
in the Art of Yugoslavia in the 1960s and 1970s', in A. Janevski (ed.), *As Soon
as I Open My Eyes I See a Film: Experiment in the Art of Yugoslavia in the 1960s
and 1970s* (exh. cat.), Warsaw: Museum of Modern Art in Warsaw, 2010, p.33.
For a different take, see Prelom Kolektiv (ed.), *SKC and Political Practices of Art*
(exh. cat.), Belgrade: Prelom Kolektiv and Škuc Gallery, 2008; available at
http://www.prelomkolektiv.org/pdf/catalogue.pdf (last accessed on 18 October 2012).

4
Text provided by the artist on 15 May 2012.

5
A closer look at feminist performance of the time would open a chasm between
those artists and movements for which a discussion of art's status was bound up
with or even secondary to their socially oriented politics (e.g. Chilean artist Lotty
Rosenfeld or the Californian women's art movement) and those who focussed their
politics solely on the art field (e.g. Marina Abramović).

6
Bojana Pejić, 'Metonymical Moves', in Tihomir Milovac (ed.), *Sanja Iveković:
Is This My True Face*, Zagreb: Museum of Contemporary Art, 1998, pp.26—41.
This text has been reprinted in Silvia Eiblmayr (ed.), *Sanja Iveković: Personal Cuts*
(exh. cat.), Innsbruck: Galerie im Taxispalais, 2001, pp.85—103.

7
This mixing and matching according to particular needs is more prevalent in
regions where institutions with an interest in policing the borders of art production
are absent, or less dominant. It is worth comparing, for instance, the work made in
California and New York at the time, with the former lacking a structured gallery
system, in high contrast to the latter's gallery and museum scene.

8
A. Janevski, 'As Soon as I Open My Eyes I See a Film', *op. cit.*, p.17.

9
'Feminism, Activism and Historicisation: Sanja Iveković talks to Antonia Majača',
op. cit., p.6.

10
See Thomas Burton Bottomore, *Élites and Society*, London: C.A. Watts, 1964. Iveković
seems to be reading the 1966 Penguin reprint.

11
The privacy of the scene is further accentuated by the fact that Iveković does not seem to perform her role comfortably — if putting on an act is what she is doing. The reclining pose seems a bit too studied, too aware of the camera's eye, and the photograph does not come across as taken by a professional.

12
See Bojana Pejić's and Silvia Eiblmayer's accounts of the role of media in Iveković's work, both in S. Eiblmayr (ed.), *Sanja Iveković: Personal Cuts, op. cit.*

13
A. Majača, 'Notes on the Tactical: A Few Aspects of Art in the Public Sphere of the New Artistic Practice in Croatia', in Marina Gržinić and Alenka Domjan (ed.), *Conceptual Artists and the Power of Their Art Works for the Present*, Celje: Kontakt, The Art Collection of Erste Bank Group, 2007, pp.39—46. The limits and opportunities occasioned by Iveković's status will be considered more methodically later.

14
The photographer was Iveković's partner at the time, Dalibor Martinis, following her directions.

15
Having presumed this, one must wonder what the person on the roof across the balcony thought he saw: a woman masturbating, or a woman masturbating and a man taking pictures of this and of the parade. The second offers much more commotion, since the photographer would have been moving about.

16
In this light, the work *Spomenik* is more than ironic, it is deeply humanist in that it recognises and acknowledges the contribution that people make to the state. Because it is not an abstract representation of 'the people' but a concrete one, and even though they remain anonymous, it reminds us that indeed people are individuals, all capable of action, agency and responsibility.

17
documenta 12 took place in Kassel from June to September 2007. Roger M. Buergel, its Artistic Director, and I, its Curator, have worked together on numerous occasions since the end of the 1980s; we curated the show jointly.

18
Letter to the author, 27 January 2012.

19
This proved to be the only way the artist could make sure institutions respected the text as part of the work. Private conversation with the artist around the time of the opening of her retrospective at the Museum of Modern Art, New York in December 2011.

20
In addition to documenta 12, the work has been exhibited in over twenty shows internationally in the past ten years, at these institutions, amongst others:

Fundació Antoni Tàpies, Barcelona (2007); Office for Contemporary Art Norway, Oslo (2008—09); Van Abbemuseum, Eindhoven and BAK — basis voor actuele kunst, Utrecht (2009); Centre Georges Pompidou, Paris, (2010); the Museum of Modern Art, New York (2011) and MUDAM, Luxembourg (2012).

21
I use the term 'neo-avant-garde' here in the sense proposed by Piotr Piotrowski in his book *In the Shadow of Yalta: Art and the Avant-garde in Eastern Europe, 1945—1989* (2005, trans. Anna Brzyski), London: Reaktion Books, 2009. The notion of the 'former West' is the topic of a large-scale research, education, publishing and exhibition project (2008—14) of the same title initated by BAK, Utrecht. For more information, see http://www.formerwest.org (last accessed on 18 October 2012).

22
These are the Thyssen-Bornemisza Art Contemporary, Vienna (2003); Kontakt, The Art Collection of Erste Group, Vienna (2006); Museum Ludwig, Cologne (2007); Museo Nacional Centro de Arte Reina Sofía, Madrid (2010); and the Museum of Modern Art, New York (2011). Two artist's proofs remain with Iveković.

23
'Feminism, Activism and Historicisation: Sanja Iveković talks to Antonia Majača', *op. cit.*, p.5.

24
The retrospectives were 'Sanja Iveković: Personal Cuts', Galerie im Taxispalais, Innsbruck (2001); 'Sanja Iveković: General Alert, Works 1974—2007', Kölnischer Kunstverein, Cologne, Göteborgs Konsthalle, Gothenburg and Funcació Antoni Tàpies, Barcelona (2006—07; 'Sanja Iveković: Urgent Matters', Van Abbemuseum, Eindhoven and BAK, Utrecht (2009); and 'Sanja Iveković: Sweet Violence', Museum of Modern Art, New York (2011). During this period, an important retrospective of the artist's works was shown in the East: 'Sanja Iveković. Trening czyni mistrza' ('Sanja Iveković: Practice Makes the Master'), Muzeum Sztuki, Łódź (2009).

25
In Yugoslavia, the beginning of an autonomous women's movement can be located in the conference 'Comradess Woman. The Woman's Question: A New Approach?', which took place in Belgrade in 1978, and which reverberated in Zagreb and other cities in the Yugoslavian Federation in the years to come. See Chiara Bonfiglioli, 'Belgrade, 1978: Remembering the Conference "Drugarica Žena. Žensko Pitanje: Novi Pristup?"/"Comradess Woman. The Women's Question: A New Approach?" Thirty Years After', master's thesis, Utrecht: Utrecht University, 2008, available at http://igitur-archive.library.uu.nl/student-theses/2008-1031-202100/MA-thesis-C. Bonfiglioli.pdf (last accessed on 18 October 2012).

26
'Feminism, Activism and Historicisation: Sanja Iveković talks to Antonia Majača', *op. cit.*, p.8.

27
See Lydia Sklevicky, 'The New New Year: Or, How a Tradition Was Tempered' (trans. Dorothea Hanson), *East European Politics and Societies*, vol.4, no.1, December

1989, pp.4—29, in B. Pejić, ERSTE Foundation and Museum Moderner Kunst Stiftung Ludwig, Vienna (ed.), *Gender Check: A Reader — Art and Theory in Eastern Europe*, Cologne: Verlag der Buchhandlung Walther König, 2010, pp.55—70. The text was first published in Croatian in *Etnološka tribina*, vol.18, no.11, 1988, pp.59—72.

28
See B. Pejić, 'The Morning After: Plavi Radion, Abstract Art, and Bananas', in B. Pejić (ed.), *Gender Check: A Reader*, *op. cit.*, pp.97—110; and C. Bonfiglioli, 'Belgrade, 1978', *op. cit.* The latter speaks even of state feminism in Chapter 2.2.

29
See Neda Božinović, 'Key Points in the History of the Women's Movement in Former Yugoslavia', in Marina Blagojević, Dasa Duhacek and Jasmina Lukić (ed.), *East European Feminist Conference: What Can We Do for Ourselves?*, Belgrade: Centre for Women's Studies, Research and Communication, 1995, pp.16—17.

30
'Reproductive labour' is the sociological term for all work done in the private sphere, mostly by women, and necessary to enable the wage earners to do just that: earn their wages. It is work necessary to industrial societies, but mostly unpaid and unseen. Second Wave Feminists started to address the issue, claiming that even certain aspects of sexuality belong to this (and not just procreation). When these aspects of reproductive labour are outsourced, they not only become visible but also enter the economy as service industry.

31
This created great trouble for those who were unemployed and therefore without access to services and rights. See Stevan Vuković, 'Troubles with Reality, or Who Was to Carry the Burden of Self-Management?', in A. Janevski (ed.), *As Soon as I Open My Eyes I See a Film*, *op. cit.*, pp.41—51. Half of the unemployed were women. See C. Bonfiglioli, *Belgrade, 1978*, *op. cit.*, p.41.

32
'Feminism, Activism and Historicisation: Sanja Iveković talks to Antonia Majača', *op. cit.*, p.5.

33
Marijan Susovski (ed.), *Sanja Iveković: Performans/instalacija*, Zagreb: Studio Galerije Suvremene Umjetnosti, 1980. The title translates as 'Performance/ Installation'. The book was published on the occasion of Iveković's first performance of *Town Crier* in December 1980.

34
This is, to my knowledge, the only time the text has been printed in its original language.

35
Letter to the author, 1 February 2011.

36
The curator's text refers to all but two of the performances included in the catalogue, *Triangle* and *Svjesni čin* (*Conscious Act*, 1979), the latter being a marginal, apolitical

work. See M. Susovski, introductory text, in M. Susovski (ed.), *Sanja Iveković: Performans/instalacija, op. cit.*, unpaginated.

37
Nataša Ilić and Dejan Kršić propose that Iveković's breakthrough is also the result of the cultural reintegration of Eastern Europe into the West. N. Ilić and D. Kršić, 'Pictures of Women: Sanja Iveković', *Afterall*, issue 15, Spring/Summer 2007, pp.73—80. It seems to me that the fact that Iveković did not orient herself towards the art market is at least as important to the manner of the reception of her work. Like other artists of her generation working outside of the gallery system, her large shows started relatively late, a feature that might have been detrimental to her economic situation, but does not seem to have done a disservice to her eventual inclusion within art history.

38
See T. Milovac (ed.), *Sanja Iveković: Is This My True Face, op. cit.*

39
'Body and the East', Moderna Galerija, Ljubljana, 7 July—27 September 1998, curated by Zdenka Badovinac. See Z. Badovinac (ed.), *Body and the East: From the 1960s to the Present* (exh. cat.), Ljubljana: Moderna Galerija, Ljubljana, 1998; reprinted by The MIT Press in 1999. The exhibition included work by over a hundred artists, such as Jiří Kovanda, Tomislav Gotovac, Raša Todosijević, Marina Abramović, Katarzyna Kozyra, Ion Grigorescu, Oleg Kulik, Komar & Melamid and Laibach.

40
Initially, only three of the photographs were bought, leaving the third point of the triangle, the shot onto Savska Street, behind. When, in 2001, the work was borrowed for Iveković's retrospective in Innsbruck, the artist supplemented the missing fourth photograph from her own archive. At some point after that, the Moderna Galerija in Ljubljana acquired another shot onto Savska Street from Ivekovic, this one without a flag, and the work was given the title *Triangle 2000+* in order to mark it as different to the edition of five referred to as *Trokut (Triangle)*.

41
B. Pejić, 'Metonymical Moves', *op. cit.*, p.30.

42
In one catalogue, Jan Verwoert refers to details that are nowhere to be seen in the print used in the exhibition: 'The way Sanja Iveković invokes the possibility of a different society in her performance *Triangle* through a rough-and-ready use of American things — a T-shirt, a novel, whiskey — as utopian signifiers could be seen in analogy with Yvonne Rainer's provocative use of American flags in a dance performance.' As mentioned earlier, the book depicted is a political theory treatise. Moreover, even early works such as *Slatko nasilje* (*Sweet Violence*, 1974) show that US products were acceptable consumer goods in Yugoslavia. Iveković is critical towards this consumerism, thus it seems unlikely that she would embrace it in a utopian ploy. However, the T-shirt seems to be a bootleg version of the logo of Arm & Hammer Baking Soda that might very well have been used in some 1970s political cause.

43
N. Ilić and D. Kršić, 'Pictures of Women: Sanja Iveković', *op. cit.*, p.79.

44
Nevertheless, there are other dangers to be considered. *Sanja Iveković: Is This My True Face*, the book published on the occasion of Iveković's participation in Manifesta 2, received public funding by the Ministry of Culture of the new Croatian Republic, as well as by the Zagreb City Council. Obviously, contemporary artists with international cachet are seen by the new nationalist government as an asset to the 'process of cultural reintegration of Eastern Europe into Capitalism'. See N. Ilić and D. Kršić, 'Pictures of Women: Sanja Iveković', *op. cit.*, p.74.

45
'WACK!: Art and the Feminist Revolution' was curated by Cornelia Butler, and included work by over 120 artists. The exhibition premiered at the Museum of Contemporary Art, Los Angeles (4 March—16 July 2007), and travelled to the National Museum of Women in the Arts, Washington, DC (21 September—16 December 2007); P.S.1. Contemporary Art Center, New York (17 February—12 June 2008); and Vancouver Art Gallery (4 October 2008—18 January 2009).

46
Iveković goes as far as to argue that this was the exhibition's 'single purpose'; see 'Feminism, Activism and Historicisation: Sanja Iveković talks to Antonia Majača', *op. cit.*, p.5. Whether this was the intention of curator Cornelia Butler is debatable. She might have been guilty of provincialism. We tend to forget that hegemony often goes hand in hand with an inability to fully understand the importance of looking beyond one's own backyard.

47
Iveković, speaking months before the opening of the show, was confident that the curator Bojana Pejić's 'insider perspective' would provide 'an important intervention into the present master narrative'. See *ibid.*, p.6. 'Gender Check: Femininity and Masculinity in the Art of Eastern Europe' was shown at Museum Moderner Kunst Stiftung Ludwig (MUMOK), Vienna from 19 November 2009 to 14 February 2010, and at Zachęta Narodowa Galeria Sztuki, Warsaw from 19 March 2010 to 13 June 2010. The exhibition was initiated by Erste Stiftung, Vienna, and included work by more than 220 artists from Eastern Europe. See B. Pejić (ed.), *Gender Check: Femininity and Masculinity in the Art of Eastern Europe* (exh. cat.), Vienna and Cologne: Museum Moderner Kunst Stiftung Ludwig and Verlag der Buchhandlung Walther König, 2009. See also B. Pejić, ERSTE Foundation and Museum Moderner Kunst Stiftung Ludwig, Vienna (ed.), *Gender Check: A Reader — Art and Theory in Eastern Europe*, *op. cit.*

48
To bring together this amount of scattered and in some cases never-exhibited work while operating from the outside of a museum as a freelance curator was a tremendous task. The academic argument behind the exhibition's structure was innovative and faultless. Yet, as with 'WACK!', an opportunity to bring forward the discourse and practice of feminist *curating* was missed, as the exhibition refrained from extending its feminist perspective beyond matters of iconography to, for example, the display.

49
Piotrowski additionally notes: 'Depending on the location and political context, the same type of art could have radically different meaning and significance in different countries of the region.' P. Piotrowski, *In the Shadow of Yalta*, *op. cit.*, p.10.

50
'With the reception of *Fountain* into the museum, and the recognition of anti-art as a legitimate genre within an expanded conception of art, the urinal itself [...] inevitably acquired the aura of art "objecthood". With the negation of *Fountain*'s anti-institutional impulse — or, at least, its consignment to history — came the return of its aesthetic dimension.' Peter Osborne, 'Survey', in P. Osborne (ed.), *Conceptual Art*, London and New York: Phaidon, 2002, pp.27—28.

51
'Women's House: Sanja Iveković Discusses Recent Projects', *ARTmargins Online*, 20 December 2009, http://www.artmargins.com/index.php/5-interviews/541-qwomens-houseq-sanja-ivekovic-discusses-recent-projects-interview (last accessed on 18 October 2012).

52
See M. Susovski (ed.), *Sanja Iveković: Performans/instalacija*, *op. cit.*, unpaginated; Z. Badovinac, *Body and the East*, *op. cit.*, pp.68—69; and Z. Badovinac (ed.), *2000+ Arteast Collection: The Art of Eastern Europe in Dialogue with the West, From 1960 to the Present* (exh. cat.), Ljubljana: Moderna Galerija, 2000.

53
See P. Piotrowski, *In the Shadow of Yalta*, *op. cit.*, pp.356—57. The original Polish edition of Piotrowski's book appeared in 2005 (Poznań: REBIS Publishing House), but I do not know whether it had an illustration of *Triangle*.

54
The worst, most probably, is the reduction of the work to the text and one photograph (the view onto Savska Street), which is integrated into the catalogue entry in *documenta 12: Kassel, 16 June—23 September 2007* (exh. cat.), Cologne: Taschen, 2007, pp.108—09. However, this catalogue was never meant to represent the artworks; it was produced in the manner of the almost extinct 'exhibition guide' genre, with images functioning solely as mnemonic aids.

55
See T. Milovac (ed.), *Sanja Iveković: Is This My True Face*, *op. cit.*, p.27.

56
N. Ilić and Kathrin Rhomberg (ed.), *Sanja Iveković: Selected Works* (exh. cat.), Barcelona: Fundació Antoni Tàpies, 2008, pp.112—13. As recently as in 2010 the work was reproduced without being faithful to its composition in *The Promises of the Past — 1950—2010: A Discontinuous History of Art in Former Eastern Europe* (exh. cat.), Zürich: Ringier, 2010. The catalogue for the 2001 exhibition at Galerie im Taxispalais, Innsbruck shows an approximation to the actual composition, but it is only after the edition of *Triangle* enters collections that the composition gets taken seriously; see S. Eiblmayr (ed.), *Sanja Iveković: Personal Cuts*, *op. cit.*

57
In recent years, Iveković has frequently sent an installation shot from this exhibition to curators and collectors as a model for installation.

58
See Z. Badovinac, *Body and the East, op. cit.*, pp.68—69.

59
With a slight amendment in *Triangle 2000+*: the addition of an alternative fourth photograph.

60
Not always is negligence the cause for a misrepresentation of the work; there might also be a conflict of interest between different styles or formats of publications and artworks.

61
For the first version, see M. Susovski (ed.), *Sanja Iveković: Performans/instalacija, op. cit.*, unpaginated.

62
These have appeared, respectively, in: Iveković's own copy and N. Ilić and K. Rhomberg (ed.), *Sanja Iveković: Selected Works, op. cit.*, p.113; Maria Hlavajova (ed.), *Sanja Ivekovic: Urgent Matters*, Utrecht and Eindhoven: BAK and Van Abbemuseum, 2009, p.42 and *documenta 12, op. cit.*, p.108; installation text provided by Kontakt, The Art Collection of Erste Group, Vienna; and installation text provided by Museo Nacional Centro de Arte Reina Sofía, Madrid.

63
'Women's House: Sanja Iveković Discusses Recent Projects', *op. cit.*

64
For a theory of fantasy and the story of origin, see Jean Laplanche and Jean-Bertrand Pontalis, *Urphantasie. Phantasien über den Ursprung, Ursprünge der Phantasie* (trans. Max Looser), Frankfurt a.M.: Fischer, 1992; originally published as 'Fantasme originaire, fantasme des origines, origine du fantasme', *Les Temps modernes*, no.215, April 1964; first English translation 'Fantasy and the origins of sexuality' published in *International Journal of Psychoanalysis*, vol.49, no.1, 1968, pp.1—18, reprinted in Riccardo Steiner (ed.), *Unconscious Phantasy*, London: Karnac, 2003, Chapter 4, pp.107—44. For the uses of enabling fantasy employed in the subject formation of an artist, see Ruth Noack, 'Zwischen Phantasie und Repräsentation. Die Selbstdarstellung als Prozeß der Subjektivierung am Beispiel des Frühwerks von Lynn Hershman', unpublished master's thesis, Vienna: University of Vienna, 1999.

65
One of the unpublished photographs documenting *Triangle* shows the same scene as the photograph in *Spomenik*, also from 1979. As Tito parades occurred frequently, the photographs of the crowd on Savska Street might have been taken during an earlier parade than those of Iveković on her balcony.

66
David Green and Joanna Lowry, 'From Presence to the Performative: Rethinking Photographic Indexicality', in D. Green (ed.), *Where Is the Photograph?*, Brighton: Photoworks/Photoforum, p.51.

67
Ibid.

68
See A. Janevski, 'As Soon as I Open My Eyes I See a Film', *op. cit.*, p.35.

69
M. Susovski, introductory text, in M. Susovski (ed.), *Sanja Iveković: Performans/ instalacija*, *op. cit.*, unpaginated.

70
'Feminism, Activism and Historicisation: Sanja Iveković talks to Antonia Majača', *op. cit.*, p.8.

71
M. Susovski, introductory text, in M. Susovski (ed.), *Sanja Iveković: Performans/ instalacija*, *op. cit.*, unpaginated.

72
Probably the first large-scale mapping that transgressed national borders was IRWIN (ed.), *East Art Map: Contemporary Art and Eastern Europe*, London: Afterall Books, 2006. See also Martina Handler (ed.), *PATTERNS — Travelling Lecture Set 2008/2009. Writing Central European Art History*, Vienna: Erste Stiftung and WUS Austria, 2008.

73
See, for instance, Lukasz Ronduda, 'Pragmatism of the Margins: On Contacts Between Yugoslav and Polish Avant-Gardes in the 1970s', in A. Janevski (ed.), *As Soon as I Open My Eyes I See a Film*, *op. cit.*, pp.53—64.

74
A similar criterion — involving the common denominator 'totalitarianism' — led to new interest in collating Eastern European and Latin American modernities. This interest is also fuelled by recent economic shifts, which have led to the rise of a new Latin and South American collectorship with enough prowess to influence Western art institutions and markets.

75
P. Piotrowski, *In the Shadow of Yalta*, *op. cit.*, p.10.

76
There is some uncertainty about the dating of this work. The artist himself dates the piece 1970, while the 1978 catalogue *The New Art Practice in Yugoslavia, 1966—1978* dates it 1971. See M. Susovski (ed.), *The New Art Practice in Yugoslavia, 1966—1978* (exh. cat.), Zagreb: Gallery of Contemporary Art, 1978, pp.78 and 109 (fig.134).

77
B. Pejić, 'Introduction: Eppur si muove!', in B. Pejić , (ed.), *Gender Check: A Reader*, *op. cit.*, p.16. Pejić's research into the gradual replacement in socialist Yugoslavia of portraits of partisan women by abstract female figures — allegories of the nation — has been fruitfully employed by a younger generation of art historians, such as Antonia Majača, to rethink public monuments.

78
See Boris Kanzleiter and Krunoslav Stojaković, '*1968' in Jugoslawien: Studentenproteste und kulturelle Avantgarde zwischen 1960 und 1975. Gespräche und Dokumente*, Bonn: Verlag J.H.W. Dietz, 2008, p.27. One of the main demands of the students was for the government to put their own policies into practice.

79
This is why it is so easily transferrable to the West, where it occupied the position of institutional critique from the East. The genealogy might be traced from Daniel Buren through Öyvind Falström, whose film *Mao/Hope March* (1966) comes quite close to Szombathy's intervention in public space, to present practices such as Sharon Hayes's.

80
See A. Janevski, 'As Soon as I Open My Eyes I See a Film', *op. cit.*, p.25, fn.31.

81
See Ješa Denegri, 'Art in the Past Decade', in M.Susovski (ed.), *The New Art Practice in Yugoslavia, 1966—1978*, *op. cit.*, pp.5—12.

82
For a critical introduction to Yugoslav modernism, see J. Denegri, 'Inside or Outside "Socialist Modernism"? Radical Views on the Yugoslav Art Scene, 1950—1970' (trans. Branka Nikolić), in Dubravka Djurić and Miško Šuvaković (ed.), *Impossible Histories: Historical Avant-gardes, Neo-avant-gardes, and Post-avant-gardes in Yugoslavia, 1918—1991*, Cambridge, MA and London: The MIT Press, pp.170—208.

83
On the politics of SKC Belgrade, see Prelom Kolektiv (ed.), *SKC and Political Practices of Art*, *op. cit.*; additional information also appears in A. Janevski (ed.), *As Soon as I Open My Eyes I See a Film*, *op. cit.* On Zagreb's SC, see several texts in M. Susovski (ed.), *The New Art Practice in Yugoslavia, 1966—1978*, *op. cit.*; and Maja and Reuben Fowkes, 'Croatian Spring: Art in the Social Sphere', paper presented at the conference 'Open Systems: Art c.1970', Tate Modern, London, 18 September 2005, available at http://www.translocal.org/research/Croatian%20Spring.htm (last accessed on 18 October 2012).

84
The exhibition 'Haustor Frankopanska 2a' ('Front Entryway', 1970—71) was organised by Braco Dimitrijević and Goran Trbuljak. See Nena Baliković, 'Braco Dimitrijević — Goran Trbuljak. Zagreb', in M. Susovski (ed.), *The New Art Practice in Yugoslavia, 1966—1978*, *op. cit.*, pp.29—33.

85
See Davor Matičević, 'The Zagreb Circle', in M. Susovski (ed.), *The New Art Practice in Yugoslavia, 1966—1978, op. cit.*, p.23.

86
J. Denegri, 'Art in the Past Decade', *op. cit.*, p.8.

87
Performances at Students' Centre galleries by Marina Abramović, Sanja Iveković or Raša Todosijević, among others, all directly invoked audience participation.

88
Self-management, originally conceived narrowly as referring to the network of workers' councils, which were to administer factories and other enterprises and thereby initiate the withering away of the state, came, in time, to be construed much more broadly, meaning worker-oriented, free, self-actualising and progressive all at the same time.' Sabrina P. Ramet, 'In Tito's Time', in S.P. Ramet (ed.), *Gender Politics in the Western Balkans: Women and Society in Yugoslavia and the Yugoslav Successor States*, University Park, PA: Pennsylvania State University, 1999, p.91.

89
B. Kanzleiter and K. Stojaković, *'1968' in Jugoslawien, op. cit.*, p.18. Translation the author's.

90
Interestingly, there seems to have been a consensus that corruption was to be tackled by disciplining individuals; if there was a discourse that analysed it as a systemic problem, it was not mainstream.

91
Sabina Ramet gives several examples: the SKJ at its Eighth Congress (1964) admitted that the increase of its female membership was still 'insignificant', but at the same time elected so few women to its Central Committee that they only amounted to 8 per cent; and even at the Eleventh Congress (1978), when Tito addressed gender inequality as a 'class', 'the assembled delegates ignored this formulation in their final program, and blamed continued gender inequality on […] "conservative prejudices"'. See S.P. Ramet, *In Tito's Time, op. cit.*, pp.100—01.

92
'Feminism, Activism and Historicisation: Sanja Iveković talks to Antonia Majača', *op. cit.*, p.6.

93
Because of its assumed political intent this act was first described as vandalism. Pupils from the Applied Arts School in Split, Pave Dulčić and Tomo Čaleta were prosecuted and later committed suicide. Since then a total of thirty people have been named as protagonists. See Ana Peraica, 'Anonymous Authors, Nameless Heroes, Unknown Histories (A Local Historical Overview of the Strategies and Motifs of the Variable)', in IRWIN (ed.), *East Art Map, op. cit.*, pp.166—67. Documentary photograph courtesy Marinko Sudac Collection, Varaždin, virtual museum http://www.avantgarde-museum.com (last accessed on 18 October 2012).

94

For a slightly different interpretation, see A. Janevski, 'As Soon as I Open My Eyes I See a Film', *op. cit.*, p.30: 'it surely becomes the first case of artistic appropriation and estrangement of a representative public space, before artistic interventions were accepted institutionally'.

95

Artist at Work also undermines the socialist fetish of work itself.

96

A. Janevski, 'As Soon as I Open My Eyes I See a Film', *op. cit.*, p.33.

97

It was this conference that sparked women's groups in other cities, for example Women and Society in Zagreb; Iveković attended their lectures. See 'Feminism, Activism and Historicisation: Sanja Iveković talks to Antonia Majača', *op. cit.*, p.8.

98

'Students were given a cultural venue as a way of channelling their dissatisfaction into a marginal cultural experience' — this is how a younger generation sees it. See A. Janevski, 'As Soon as I Open My Eyes I See a Film', *op. cit.*, p.33.

99

Đorđević did receive written answers from Vito Acconci, Carl Andre, Susan Hiller, Daniel Buren, Hans Haacke, Lucy Lippard, Sol LeWitt, Tom Marioni, Zoran Popović, Mel Ramsden, Raša Todosijevic and Lawrence Weiner.

100

Jelena Vesić, 'Note', in Prelom Kolektiv (ed.), *SKC and Political Practices of Art*, *op. cit.*, p.5.

101

See Boris Buden, 'Behind the Velvet Curtain: Remembering Dušan Makavejev's *W.R.: Mysteries of the Organism*', *Afterall*, issue 18, Summer 2008, pp.119—26.

102

S.P. Ramet, *In Tito's Time*, *op. cit.*, p.91.

103

Michel Foucault, '*The Subject and Power*': *Beyond Structuralism and Hermeneutics* (ed. Hubert L. Dreyfus and Paul Rabinow), Chicago: University of Chicago Press, 1983, pp.208—26.

104

See J. Denegri, 'Art in the Past Decade', *op. cit.*; and Margit Rosen, *A Little-Known Story about a Movement, a Magazine, and the Computer's Arrival in Art: New Tendencies and Bit International, 1961—1973*, Karlsruhe, Cambridge, MA and London: ZKM and The MIT Press, 2011.

105

There was also some awareness of contemporary production and discourse in other Eastern European countries, though I cannot find evidence of exhibitions of what

was mostly considered dissident art in the Soviet Block states. However, it seems that there was no South-North exchange to speak of. Production in Asia or South America was not known. Even though the country's political affiliation with other non-aligned states, such as India, might have lead to a fruitful exchange, the hegemony of the West (which, at that point, included the US, the UK, northern Europe, France and Italy) concealed all else.

106
It later turned into the Muzej Suvremene Umjetnosti (Museum of Contemporary Art), Zagreb.

107
Lewis Siegelbaum, '1924: Workers' Clubs', *Seventeen Moments in Soviet History*, 'http://www.soviethistory.org/index.php?page=subject&SubjectID=1924clubs&Year=1924 (last accessed on 18 October 2012).

108
See, for example, the early writings of feminists Iris Marion Young, Nancy Fraser, Carole Pateman or Carol Hagemann-White.

109
See Luc Boltanski and Éve Chiapello, *The New Spirit of Capitalism* (1999, trans. Gregory Elliott), London: Verso, 2005. I am arguing here that the disbanding of the welfare state has influenced not only the social but also the cultural sector in similar ways, shifting responsibility to individuals who may or may not be equipped and positioned to act upon their freedom from the state. In some instances, socially engaged art has served to conceal the extent to which individuals carry the risks governments have taken, and how they suffer the consequences.

110
See A. Majača, 'Notes on the Tactical', *op. cit.*

111
This fact and the following digest is sourced from S.P. Ramet, *The Three Yugoslavias: State-Building and Legitimation, 1918—2005*, Washington, DC: Woodrow Wilson Center Press, 2006.

112
In economic terminology the term 'liberalisation' does not necessarily imply an ideology of freedom. Neither do I wish to imply that certain economic policies translate automatically into a more just society.

113
It is misleading because it refers in name to the Prague Spring, which had a different ideology and impact, though both were dissident mass movements under communist governments in Eastern Europe. On the Prague Spring and its ideological differences to the student movement in Western Europe, see Jacqes Rupnik's interview with Rudi Dutschke: 'The Misunderstanding of 1968', *The European Journal of International Affairs*, no.6, 1989; reprinted at *Eurozine*, 16 May 2008, http://www.eurozine.com/articles/2008-05-16-dutschke-en.html. See also J. Rupnik, '1968: The Year of Two Springs' (trans. Mike Routledge), *Transit*, no.35, 2008; preprinted at *Eurozine*, 16 May 2008, http://www.eurozine.com/articles/2008-05-16-rupnik-en.html (both last accessed on 18 October 2012).

114
S.P. Ramet, *The Three Yugoslavias, op. cit.*

115
One year, farmers slaughtered 50,000 sheep in protest to collectivisation. See *ibid.*, p.195.

116
It was prone to corrupt decision-making, which resulted in, amongst other things, a rising need for imports. *Ibid.*

117
The distribution of foreign currency was severely criticised by Slovenia and Croatia, who received only a miniscule amount of the foreign currency they were accruing. For example, by 1969 Croatia brought in 50 per cent and received only 15 per cent. *Ibid.*, p.228.

118
Ibid., pp.205 and 222.

119
For example, money that was awarded by the World Bank for a road to be built through Slovenia and Croatia was redirected to Macedonia. *Ibid.*, p.224. On the other hand, when nationalist Croatia claimed a part of Bosnia for itself (on the grounds of some argument about ethnic minorities), Serbia countermanded this not by a show of solidarity with the Bosnian republic, but by insisting on its own rights to the land. *Ibid.*, pp.251—55.

120
An example of chauvinism includes the Serbian streamlining of Yugoslavian dictionaries and schoolbooks. On the other hand, what was seen as biopolitics (a demographic displacement of Croats in Croatia) can also be read as effect of economic migration. Both chauvinism and modernism might not even have excluded each other; in fact, one might argue that the Yugoslav example shows the chauvinism in Modernity. See Hito Steyerl's video *Journal No.1 — An Artist's impression* (2007), produced for documenta 12.

121
These two are often conflated, as many republics had a mix of ethnic populations. Serbs and Croats, for example, would have had an interest in the prosperity of the Croatian republic, as they would have profited from it directly. The formation and self-identification along primarily ethnic lines was at least in part a product of a nationalist, even racist identity politics, with religion added to the mix.

122
Miko Tripalo, quoted in S.P. Ramet, *The Three Yugoslavias, op. cit.*, p.237.

123
The racism was directed against the 15 per cent of Serbians living in Croatia. For a discussion of student participation in the Croatian Spring, see B. Kanzleiter and K. Stojaković, *'1968' in Jugoslawien, op. cit.*

124
Sociologist László Székely, quoted in *ibid.*, p.43.

125
'Feminism, Activism and Historicisation: Sanja Iveković talks to Antonia Majača',
op. cit., p.6.

126
'Some of the most official cultural products of the Socialist Federal Republic
of Yugoslavia (SFRJ) insisted upon artistic autonomy and on creating a certain
political and aesthetic distance from the directly visible ideology'. Branislava
Anđelković, 'How "Persons and Objects" become Political in Sanja Iveković's
Art', in N. Ilić and K. Rhomberg (ed.), *Sanja Iveković: Selected Works, op. cit.*, p.20.

127
B. Anđelković argues that this is Želimir Žilnik's form of dissidence. See *ibid.*,
pp.20—21.

128
Censorship was not inevitable, however, even in the other arts: Žilnik's film
about the homeless was censored. Yet, films by the Sarajevo Documentary School
that criticised the lack of a public discourse on poverty or thematised conflict
around squatters were shown in regular theatres. As one of the directors said after
a screening at the International Short Film Festival Oberhausen, 4 May 2009,
as long as Tito was left out of the picture, they could pretty much show anything.

129
This is not particular to the Zagreb scene. Nor is the erroneous dichotomy of
totalitarianism and subversion — a dichotomy which holds the individual prisoner
of an impossible agency. The artist is at once thought too powerful, able to intervene
in and crack the unity of public space (which in reality never cohered in the first
place, even as an image) and at the same time deemed unable, for various reasons,
to fulfil a truly political role in society.

130
See D. Djurić and M. Šuvaković (ed.), *Impossible Histories*, Cambridge, MA and
London: The MIT Press, 2003; M. Rosen, *A Little-Known Story, op. cit.*; and M. and
R. Fowkes, *Croatian Spring, op. cit.*

131
Ibid., p.10. *Grounded Sun* had black paint spilt over it on two occasions before
being burned to the ground during the Croatian Spring (1971). In 1994, a bronze
version of the original work was placed in Bogoviceva Street, also in central Zagreb.
See M. and R. Fowkes, 'Croatian Spring: Art in the Social Sphere', *op. cit.*

132
J. Denegri, 'Art in the Past Decade', *op. cit.*, p.10.

133
The artist's group EXAT 51 (an abbreviation of Eksperimentalni Atelje —
Experimental Studio), active between 1950 and 1956, intended to create a
contemporary socialist society by integrating abstract art into everyday life and

abolishing the boundaries between fine and applied arts. Their interest reached towards design, architecture and urban planning. They were based in Zagreb, but their scope was international. Some of the members formed the basis of the international movement Nove tendencije (New Tendencies) that was formed in Zagreb in 1961. Gorgona, founded in 1959 by visual artists, architects and art critics, 'did nothing, just lived'. Renown for their anti-institutional gestures, they strongly influenced a younger generation through personal contact and their journal *Gorgona* (1961—66). See, amongst a large body of literature, D. Djurić and M. Šuvaković (ed.), *Impossible Histories, op. cit.*

134
Leslie McCall, 'The Complexity of Intersectionality', *Journal of Women in Culture and Society*, vol.30, no.3, Spring 2005, pp.1771—1800; available at http://www.journals.uchicago.edu/doi/pdf/10.1086/426800 (last accessed on 18 October 2012).

135
B. Anđelković, *How 'Persons and Objects' become Political*, in N. Ilić and K. Rhomberg (ed.), *Sanja Iveković: Selected Works, op. cit.*, p.22.

136
See M. Foucault, 'Das Spiel des Michel Foucault (Gespräch)', in Daniel Defert, Francois Ewald and Jacques Lagrange (ed.), *Michel Foucault. Schriften in vier Bänden. Dits et Ecrits, Vol.3*, Frankfurt a.M.: Suhrkamp, 2003, p.392.

137
Iveković has mentioned this on numerous occasions, including in a phone conversation with the author, 20 July 2010.

138
See catalogue entry in N. Ilić and K. Rhomberg (ed.), *Sanja Iveković: Selected Works, op. cit.*, p.41.

139
Lecturing students in Montréal in 1978, Godard goes on to tell them that commercial films consist of one image repeated 800 times over; in fact, the same films are shown again and again with different titles — people simply don't notice, 'because they are completely exhausted from their work at the university or the factory'. Quoted in Klaus Theweleit, 'One + One', in Astrid Ofner (ed.), *Jean-Luc Godard: Eine Textauswahl* (exh. cat.), Vienna: Viennale 1998, p.11. Translation the author's.

140
See Kaja Silverman, 'The Female Authorial Voice', *The Acoustic Mirror: The Female Voice in Psychoanalysis and Cinema*, Bloomington and Indianapolis: Indiana University Press, 1988, pp.187—234.

141
For instance, the women artists who showed with Iveković at Trigon in 1973. She mentions being very impressed with Hannah Wilke's work, as well as with Lynda Benglis's 1974 *Artforum* advertisement, which she accessed through the library at the US embassy in Zagreb.

142
Phone conversation with the author, 10 July 2010.

143
Despite their critique of the government, they defended the system of central government, maybe out of an awareness of what might happen if the fragile pact between republics were ever shattered (as it eventually was).

144
Danko Grlić, 'Practice and Dogma', *Praxis*, no.1, 1965, pp.49—58. The journal, which was published until 1975 from Zagreb, was a platform for philosophers and political scientists from East and West. The group also organised an infamous summer school on the Island of Korčula from 1964 to 1974, which was attended by international guests like Jürgen Habermas, Henri Lefebvre and Herbert Marcuse.

145
Their anti-separatist ideology did not keep them from censorship. In 1975, the internationally published *Praxis* journal was closed by the government and members of the Belgrade section of the Praxis Group were expelled from the Faculty of Philosophy of the University of Belgrade.

146
B. Kanzleiter and K. Stojaković, *'1968' in Jugoslawien*, *op. cit.*, p.22. Translation the author's. How much of this discourse on individualism is due to the economic changes and the strengthening consumerism is difficult to ascertain.

147
Generally, the Eastern European practices of self, be it Ion Grigorescu's work or Natalia LL's, recognise the influence of politics on the subject. The 'political is personal', as Edith Andras phrased it at the symposium 'Reading Gender: Art, Power and Politics of Representation in Eastern Europe', Museum Moderner Kunst Stiftung Ludwig, Vienna, 14 November 2009.

148
Iveković's first activist works started in 1994, commissioned by the coalition of Croatian women's NGO, the most famous of which is *Ženska kuća* (*Women's House*, 1998—ongoing). Over the years, Iveković has also contributed continuously to women's organisations by making posters and doing graphic design for them.

149
Though the work includes a statement by Baldessari signed 1975, the exhibition catalogue of 'Tendencies' from 1973 shows two of the photographs and list all five. My thanks to Darko Fitz for this information.

150
This is due to the cropping and placement of the sentence, since the criterion of ugliness only makes sense in a sexualised context.

151
The verbalisation of an explicit feminist stance probably always needs involvement with other feminists, which for Iveković started in the Women and Society group.

152
B. Pejić, 'Metonymical Moves', *op. cit.*, p.32.

153
Ibid., p.32.

154
In a later text, Pejić differentiates her terminology: 'the very term public space implies a democratic public sphere, which did not and could not come into existence under state-Socialism'. B. Pejić, 'Public Cuts', in N. Ilić and K. Rhomberg (ed.), *Sanja Iveković: Selected Works*, *op. cit.*, p.238.

155
B. Pejić, 'Metonymical Moves', *op. cit.*, p.32.

156
The concept of a visual order shifts to the realm of visuality all aspects of the *dispositif*, though it should be clear that visuality in itself is historically contingent and a product of the *dispositif*. See Sophia Prinz, 'Visuelle Formationen. Über das Verhältnis von Dingen, Subjekten und Praktiken des Sehens', unpublished doctoral thesis, Frankfurt/Oder: Europa-University Viadrina, 2012. It remains unclear in what way this visual order is particular to Yugoslavia, since it is deduced from a Western concept of the split between public and private, and, after the Kennedy assassination, security officers would most probably have reacted similarly anywhere on the globe. A generic visual order would tie in with the feminist notion that patriarchy is all pervasive; however, it would then need to be tied more specifically to the proposition of a communist totality in public space.

157
Susan Gal and Gail Kligman, *The Politics of Gender After Socialism: A Comparative-Historical Essay*, Princeton: Princeton University Press, 2000, p.48.

158
See catalogue entry in N. Ilić and K. Rhomberg (ed.), *Sanja Iveković: Selected Works*, *op. cit.*, p.107. The show 'Innovacije' ('Innovations') took place at Galerija Karas, Zagreb in 1977.

159
The work, following the accompanying text, is titled, *Likovni radnik u svom radnom prostoru pri radu* (*Artist Working on Her New Piece in Her Workplace*, 1977).

160
S. Gal and G. Kligman, *The Politics of Gender After Socialism*, *op. cit.*

161
Paul Lafargue, *The Right To Be Lazy* (1880), quoted at http://www.dkrenton.co.uk/research/lafargue.html (last accessed on 18 October 2012).